what logos do
and how they do it

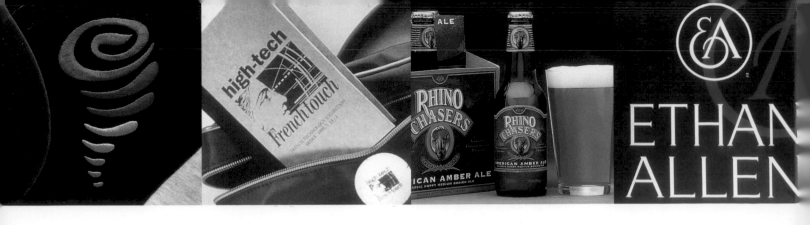

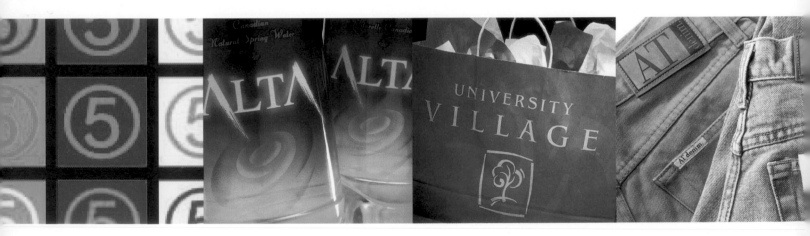

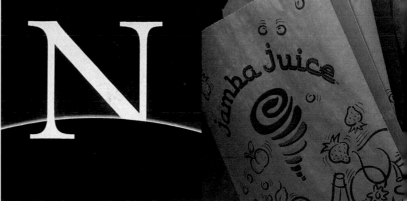

what logos do
and how they do it

GLOUCESTER MASSACHUSETTS

ROCKPORT
PUBLISHERS

Anistatia R Miller and Jared M. Brown

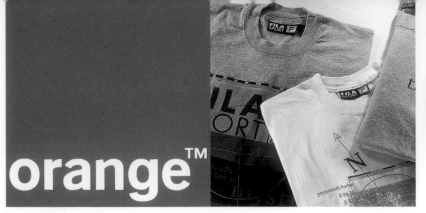

First published in the United States of America by:
Rockport Publishers, Inc.
33 Commercial Street
Gloucester, Massachusetts 01930-5089
Telephone: (978) 282-9590
Facsimile: (978) 283-2742
www.rockpub.com

ISBN 1-56496-705-0

10 9 8 7 6 5 4 3 2

Designer: ARK Design/NY

Printed in China.

Image Credits: Front cover images, top row (l to r): The Coca-Cola Company/Powerade (p. 20), Best Cellars (p. 28), Alki Bakery & Café (p. 27), FutureTense (p. 92), Apria (p. 76); middle row (l to r): Jamba Juice (p. 12), @Home Network (p. 91), CIGNA (p. 74), Technicolor (p. 87), Muse Technologies (p. 121); bottom row (l to r): Channel 5 (p. 89), Elseware Corporation (p. 107), Christiansen, Fritsch, Giersdorf, Grant & Sperry, Inc. (p. 116), Netscape Communications (p. 88), Scholastic Network (p. 92).

Spine images (l to r): XactData Corporation (p. 113), The Coca-Cola Company/Powerade (p. 20), Ann Taylor (p. 62), Ethan Allen (p. 30).

Back cover images (l to r): Ann Taylor (p. 62), FilaSport (p. 68), Corbis Corporation (p. 104), Caja de Pensiones (p. 123), XactData Corporation (p. 113), The X Files (p. 90).

Back flap image: 1996 Summer Olympic Games (p. 99)

Half-title page images (l to r): Mark Cross (p. 70), Elseware Corporation (p. 107), Christiansen, Fritsch, Giersdorf, Grant & Sperry, Inc. (p. 116), The Coca-Cola Company/Powerade (p. 20), Ann Taylor (p. 62).

Title page spread images, left page, top row (l to r): Jamba Juice (p. 12), High-Tech (p. 97), Rhino Chasers (p. 22), Ethan Allen (p. 30); middle row (l to r): Pacific Coast Feather Company (p. 35), XactData Corporation (p. 113), The Coca-Cola Company/Powerade (p. 20), Muse Technologies (p. 121); bottom row (l to r): Channel 5 (p. 89), Alta Beverage Company (p. 26), University Village (p. 34), Ann Taylor (p. 62).
Right page (l to r): Ann Taylor (p. 62), @Home Network (p. 91), Netscape Communications (p. 88), Jamba Juice (p. 12).

Copyright page images (l to r): Orange (p. 40), FilaSport (p. 68), LG Group (p. 59).

Contents page images, top: Apria (p. 76); bottom row (l to r): Ann Taylor (p. 62), XactData Corporation (p. 113), Technicolor (p. 87).

contents

introduction

Logo design. If the Thin Man mysteries' author Dashiell Hammett had written the scenario, it might have gone something like this:

The new CEO called a meeting with the company's marketing director and the art director. A young secretary in a bottle-green shift led them into the boardroom, unceremoniously tossed a few million in contracts at the CEO, and left, pulling the carved-oak doors closed behind her. "This company needs to work on its image," the CEO announced, lighting a fresh Havana cigar and exhaling a thick cloud of blue smoke. Glancing at the marketing director, he said, "First, I want a capabilities brochure. You've got about three thousand words to sum up what the company is all about, where we come from, and where we're heading. Use words our clients'll understand. Make it speak to them. Make it current. Of course, I want it by yesterday. But don't worry, you can change it next quarter."

Then he turned to the art director, "From you we need a logo. Basically, I want you to do the same thing as the marketing director. Only you get to do it in one little symbol. A symbol that will be seen by a hundred times more people than will ever read the brochure. And by the way," he added while absently thumbing his white silk suspenders, "I want something that will last forever."

This story is more than a dramatization of what happens daily in offices around the world. It's how the logo-design process usually gets started. It seems that whenever a new company is developed or an established firm reinvents itself, a designer or a studio is commissioned to synthesize the entire firm into a compact, efficient visual representation.

When was the first logo designed? Condensing personal or business images is as ancient as the desire to brand possessions and personal achievements with icons that declare simple yet strong declarations such as "I own this" or "I made that." Nearly seven thousand years ago Transylvanian potters were inscribing their personal marks on the earthenware they created. If one made better pots than another, it's a safe bet that his mark took on more intrinsic value than that of his competitors. Egyptian, Greek, and Roman craftsman also carved or stamped their initials into their works. However, it was ancient religious sects that created some the best-known logos: the Christian cross, the Judaic Star of David, and the Islamic crescent moon.

Medieval kings and nobles impressed their royal seals and coats of arms on everything from clothing, armor, flags, and shields to tableware, entryways, and manuscript bindings. Visually depicting a lord's lineage, aspirations, or familial virtues, these symbols also served as eloquent reminders to cavalry, infantry, and mercenaries of who they were fighting for on the battlefields.

By the 1400s, the trademark had emerged as a symbol of an individual's professional qualifications to perform a particular skill. The caduceus on a physician's sign assured potential patients that the doctor was a well-trained practitioner of the medical arts. The angle and the compass symbolized the stoneworking craft—an honorable profession that built the huge cathedrals, universities, and castles of the period. These seemingly simple graphics carried so much socioeconomic and political weight that government offices were established throughout Europe during the 1500s and entrusted with the duty to register and protect the growing collection of trademarks used by the numerous craft guilds.

It didn't take long for the concept of visually trademarking one's business to spread when the Industrial Revolution shifted the political and economic balance of Europe and the Americas in favor of nonagricultural enterprise. By the late 1890s, business was booming worldwide, and so was corporate consciousness. The terms *corporate image* and *brand identity* didn't enter the general business/design vocabulary until the late 1940s, but less than twenty years later, they were elemental keys to success according to the fresh breed of college-educated marketing executives.

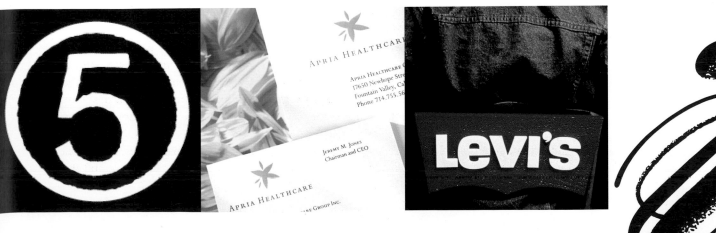

Contemporary logo designs don't follow the same superficial common denominators applied by legendary image makers such as Paul Rand (creator of the IBM, UPS, ABC-TV, and Westinghouse logos) and the design team of Massimo and Lela Vignelli (creators of the Knoll Design, Bloomingdale's, and Lancia logos). During the 1960s and 1970s, monograms, geometric shapes, bold sans serif typefaces, and crayon colors were the only acceptable construction tools used to create these unique visual identities. The recent trend, however, seems to be leaning in the same direction as big business itself, taking a light, open, diversified, and sometimes whimsical approach. Logos are now designed to appeal on a more personal level to their intended audiences and to accommodate a wider variety of applications than they have in the past.

What does the new breed of logos share with its myriad predecessors? It delivers a clear, well-defined message of uniqueness and individuality. Many times, logos are the first and only impression consumers encounter when they are shopping for a particular product or service. A great logo must say something about the company it represents. Distilling a client's persona, mission, or market approach into a single gesture or emotion that can be conveyed by a strong stand-alone image is the heart and soul of the logo-design process. The finished design also must combine timeliness with timelessness and tradition with trend in a balance appropriate to the client's needs and consumers' desires. Successful logos, trademarks, and icons must be versatile, legible, and familiar. They must be equally

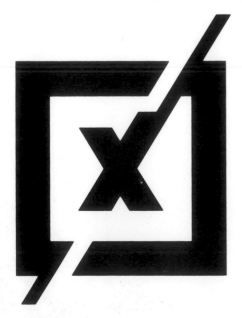

legible on the corner of a business card or on the side of a delivery truck. They must be easy to reproduce on paper, plastic, fabrics, and metals or less tangible media such as television or Internet broadcasts. They must be easily interpreted at a glance by a broad audience of viewers, breeding a high level of familiarity between the intended message and its recipient.

Reviewing the client's needs, investigating the places where the design will be seen, and selecting the right visual cues are only a small portion of the job. The real answer can only be found once you've uncovered the logo's primary motive—what it's trying to tell its audience. You have to be a great "visual detective" to find the best logo design solution.

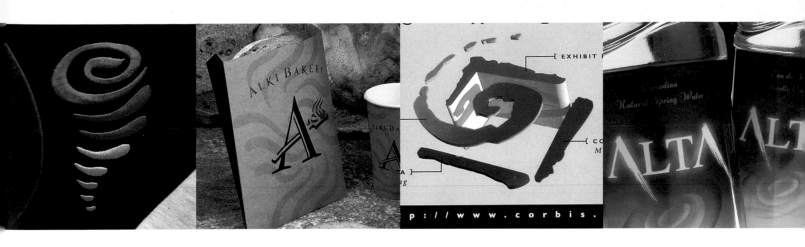

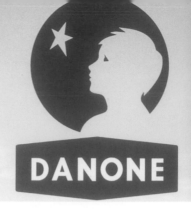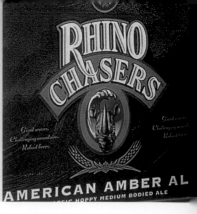

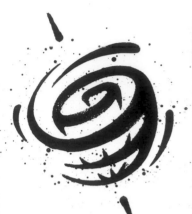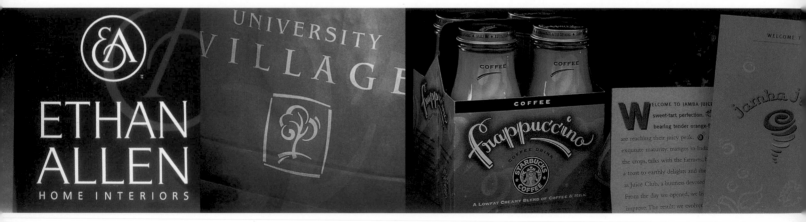

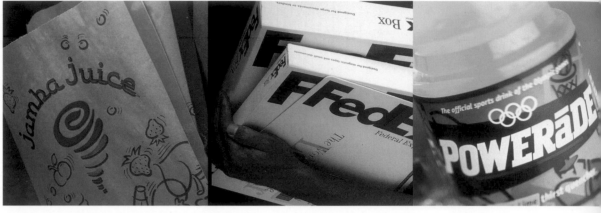

delivering
the basics

the visual focus that makes your client's restaurant, packaged food or beverage, property development, automobile, or shipping service appealing to its intended audience requires more research than a trip to the supermarket, a meal in a restaurant, a test-drive in the latest model car, or a stroll through the newest shopping complex. Understanding your client's business is not enough. You've got to understand what consumers want from your client and search for a succinct visual statement that clearly says: "Don't worry. We have exactly what you want."

It's not easy to develop a mark that stands out amid myriad competitors, especially one that clearly portrays the product's or service's point of difference. It's difficult to highlight intangible concepts in a single image that depicts comfort, security, and familiarity. But it is this type of branding that influences consumers' decisions to purchase one product or service over another.

food and beverage

food and shelter were our two most basic needs even before we transported ourselves out of the swamps. There are hundreds of thousands of food, beverage, and restaurant businesses that offer consumers opportunities to fulfill their needs. Effective logos for these establishments visually display traditional messages such as "We sell fresh ingredients" or "We will serve you great food" or more market-segment-specific messages such as "We'll help you feel young again" or "This is the place to see and be seen in" or "Your kids will love it here, but it will still be affordable." Your design solution for food, beverage, and restaurant clients must be taste-tempting. It must convince consumers that they are hungry for your client's product. It must promise complete satisfaction once the item has been consumed. It must guarantee that subsequent experiences with the product will be equally pleasurable.

CLIENT: Jamba Juice
San Francisco, California
DESIGN FIRM:
Hornall Anderson Design Works, Inc.
Seattle, Washington
ARCHITECT: Backen Arrigoni & Ross
San Francisco, California
ART DIRECTOR: Jack Anderson
DESIGNERS: Jack Anderson,
Lisa Cerveny, Suzanne Haddon, Cliff Chung
ILLUSTRATOR: Mits Katayama

Collaborating with the architect, HADW designed complementary promotional and point-of-purchase materials that conveyed a fresh, lively, and cohesive message in the chain restaurant's California-style natural wood and white-walled settings.

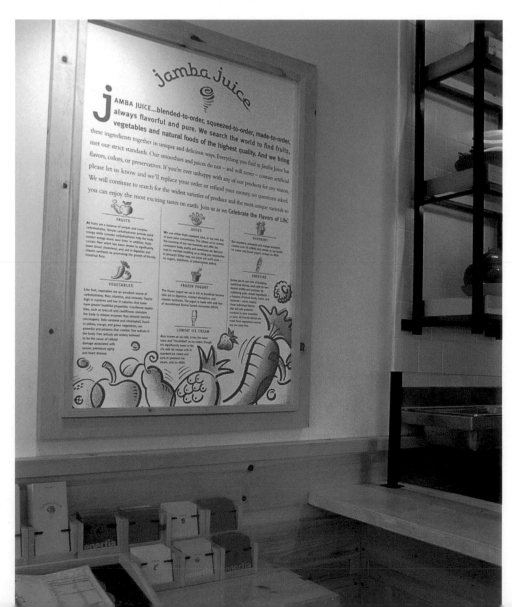

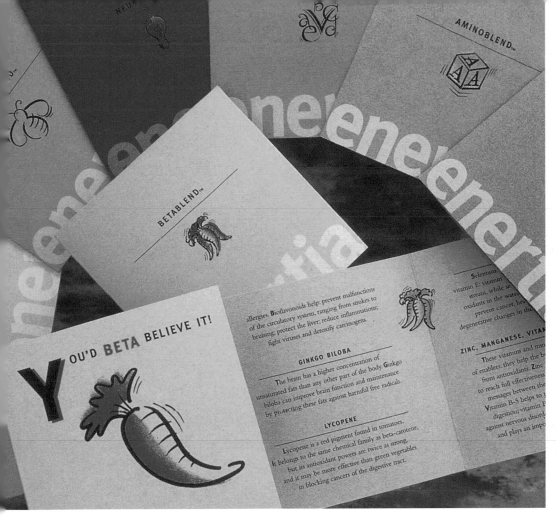

BETABLEND™

YOU'D BETA BELIEVE IT!

allergies. Bioflavonoids help: prevent malfunctions of the circulatory system, ranging from strokes to bruising; protect the liver; reduce inflammations; fight viruses and detoxify carcinogens.

GINKGO BILOBA

The brain has a higher concentration of unsaturated fats than any other part of the body. Ginkgo biloba can improve brain function and maintenance by protecting these fats against harmful free radicals.

LYCOPENE

Lycopene is a red pigment found in tomatoes. It belongs to the same chemical family as beta-carotene, but its antioxidant powers are twice as strong, and it may be more effective than green vegetables in blocking cancers of the digestive tract.

Selenium... vitamin E; vitamin... stream, while se... oxidants in the wate... prevent cancer, hea... degenerative changes in th...

ZINC, MANGANESE, VITAM...

These vitamins and man... of enablers: they help the b... from antioxidants. Zinc... to reach full effectiveness... messages between the... Vitamin B-5 helps to... digestion, vitamin B... against nervous disord... and plays an impo...

Jamba Juice's consumer-information cards explain the company's healthy food philosophy, product line, and environmental consciousness.

Theme-based restaurant chains such as TGIFriday, Pizzeria Uno, and Tony Roma's have nationally branded identities that clearly state the type of food and entertainment experience customers will find at each place. However, the most successful and competitive restaurant-related market in North America is the fast-food category. Catering to a broad age range, these venues not only promise consumers quickly prepared and good-quality meals at reasonable or low prices but also often offer value-added incentives such as an easily identifiable atmosphere and a non-food-related entertainment experience. For example, McDonald's offers children's play areas, Ronald McDonald toys and games, and blockbuster motion-picture tie-in items such as collectible Star Wars glasses. Ben & Jerry's Scoop shops offer a childlike sense of fun by selling T-shirts, book covers, and novelty items along with homemade ice cream products. In direct contrast to these, Starbucks Coffee offers adults a comfortable place where they can relax with a cappuccino or latté in an ambient, upscale coffeehouse atmosphere or purchase

Consumers do not live on
bread alone—they purchase
peanut butter, jam, soda,
and other packaged foods and
beverages daily. The reason they
choose one particular product
brand more than ten other com-
petitors depends, in part, on how
they react to the product's over-
all identity. When designing a
food or beverage logo, you
should pay special attention to
the color palette you select. You
should try to avoid dusky or
earthy tones that scientists have
proven remind both people and
animals of decomposed matter.
However, fresh, bright hues such
as tomato red, lemon yellow,
sunshine orange, and blueberry
blue aren't the only color
schemes that attract attention.
Dark, clear shades such as
raspberry red, spinach green,
and pumpkin also can be
considered prime candidates.

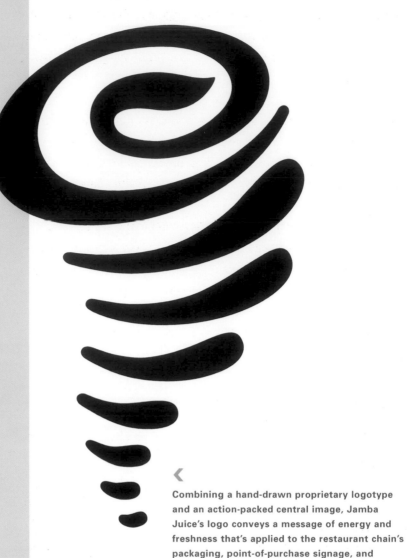

<

Combining a hand-drawn proprietary logotype
and an action-packed central image, Jamba
Juice's logo conveys a message of energy and
freshness that's applied to the restaurant chain's
packaging, point-of-purchase signage, and
promotional materials.

coffee-making and drinking items. However, it was up to the designers
of each of these identities to sum up these concepts in a single,
visual work.

Located in San Francisco, California, Jamba Juice Company focuses
on serving blended-to-order smoothies, freshly squeezed juices, and
healthy snacks through their outlets situated in shopping malls
and independent storefronts. The company commissioned Hornall
Anderson Design Works (HADW) in Seattle to develop a logo and
marketing program that would appeal to a broad audience
and distinguish this fruit-and-vegetable–oriented chain from its fast-
food pizza and burger competitors. The design team focused on
creating an image that would say that Jamba Juice Company is festive
and fun without appearing trendy and that would appeal to both

children and adults. The visual message of both the logo and the trade dress (the graphic applications used at the individual stores) also had to communicate that Jamba Juice is the authority on juice and nutrition—that it serves a quick, healthy "meal in a cup."

Leafy green, sunny lemon yellow, and ripe-tomato red head up a palette of six bright colors (including orange, purple, and raspberry) that stand out like the harvest of a summer vegetable garden to convey both the festive, natural ambiance of the stores and the promise of freshness and health of the products.

The swirling logo was inspired by the juice blenders used in the stores. Energy is further conveyed as the spiral ascends and transforms into an abstract leaf, subliminally reinforcing a feeling of dynamic activity that is associated with good health. Fun and festivity were introduced through the identity program's subordinating images. HADW commissioned illustrator Mits Katayama to create the lively tossed salad of playful yet sophisticated fruits and vegetables that appear as subordinating images on the packaging, posters, and consumer-information cards.

>
Using two highly legible typefaces— Bembo and Meta—and garden-fresh colors, Jamba Juice's menu reflects the healthiness and accessibility of this fast-food chain's product.

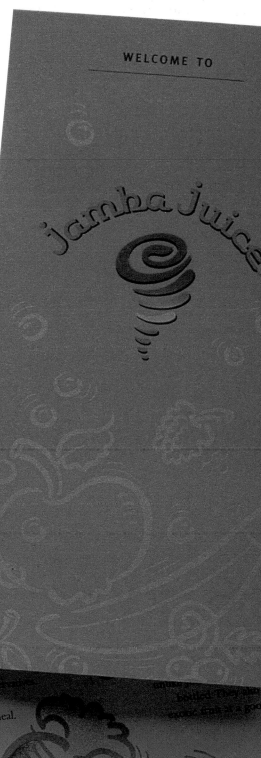

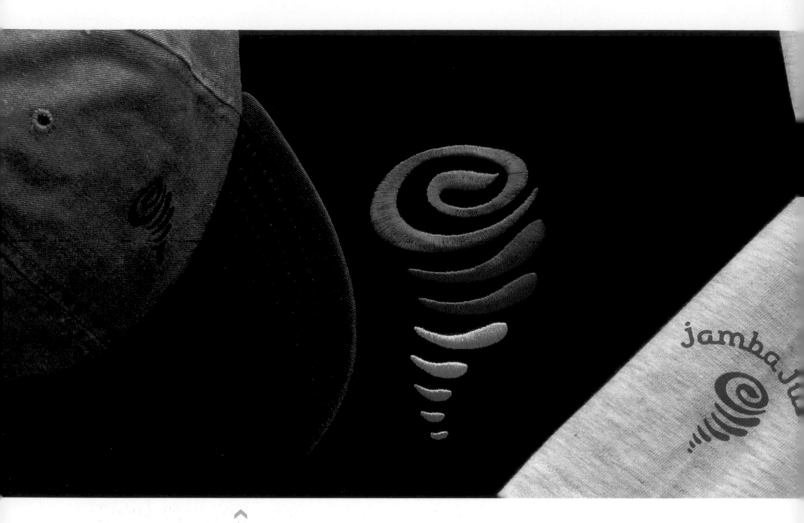

∧

Staff uniforms are an integral part of a restaurant's identity program. Jamba Juice's caps, shirts, and aprons reinforce the company's branded message with an upscale tone that creates a strong point of difference.

Most logotypes developed at HADW begin with an existing font that is modified to attain the desired individual look. In the case of Jamba Juice, a proprietary typeface was hand drawn to achieve the intended visual message. To strengthen this light, accessible typographic image, a very classic Italian serif typeface—Bembo—and a modern European sans serif typeface—Meta—were chosen as subordinating logotypes used on the menus and promotional materials because of their friendly, easy-to-read appearance. The combination clearly conveys the idea of clean, simple, and natural on the company's printed materials.

HADW applied the Jamba Juice logotype and illustrations not only to conventional carry-out items such as bags, cups, and boxes, but also to brightly colored information cards that are displayed on an information counter. These consumer information cards explain Jamba's philosophy and products and are essential tools in the company's marketing strategy.

Simplicity is the ultimate sophistication.
—*Leonardo da Vinci*

Carry-out containers are essential
marketing tools in the fast-food
industry. Jamba Juice's bags, boxes, and
cups mirror the natural wood accents of
the restaurants' interiors and the fresh-
from-the-garden feeling of a basketload
of fruits and vegetables.

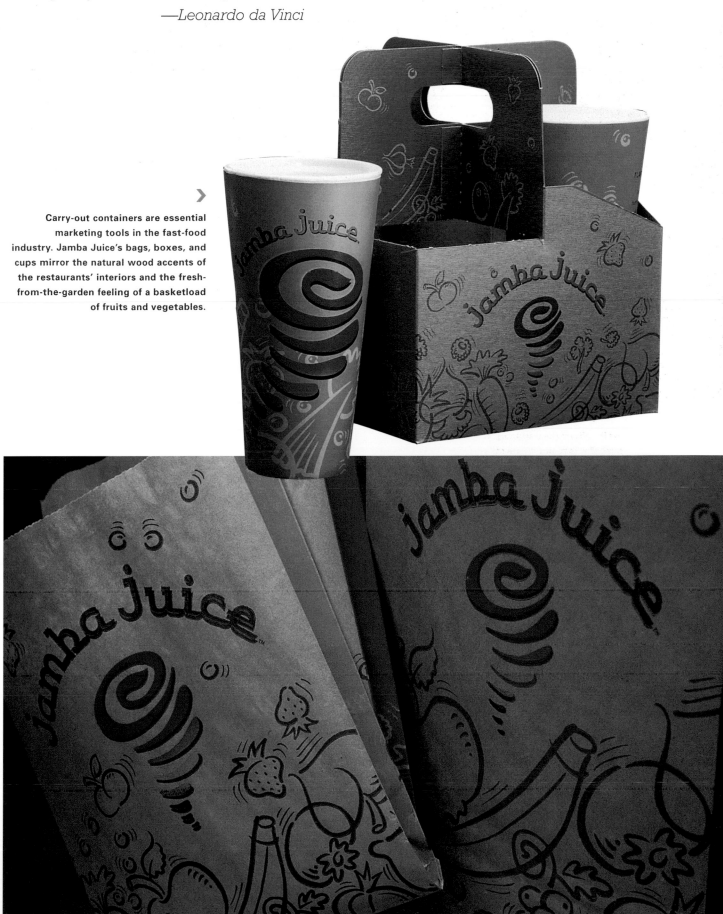

SIMPLE IS BEST

When the Wolff Olins design team set out to change the identity of the Cearns & Brown product line, team members felt that it was important that the core idea—the theme that would drive the entire visual campaign—should be very simple and direct. It's difficult enough to find a well-defined visual hook that can create a unique identity in the mind's of viewers, but the design had to achieve this balance between a product line of five hundred individual items and the total company's profile. Another challenge was the timing. The team had three months to design and produce the entire program. This may seem like an extreme example, but it's the best way to state our case for developing logos that are simple and direct. You never know where your logo will appear after you've designed the main image, the stationery, and possibly some signage and packaging. Companies expand their interests and marketing tools rapidly these days, so your final solution should be crisp and flexible enough to embrace as many applications as the client can conjure up.

In the fast-food and theme-restaurant industries, trade dress often goes beyond the interior design of the stores; the staff uniforms also establish brand identity. Casual, yet upscale embroidered baseball caps as well as silk-screened T-shirts and embroidered aprons also carry the Jamba Juice identity, reinforcing a green-grocer image in consumers' minds as they order their meals. These items are also made available for purchase by consumers.

The complete graphic package positions this chain as a unique alternative to other offerings in this highly competitive market without compromising its essential selling points: nutrition and health. Its accessible blend of bright colors and casual style brand its essential identity as an affordable fast-food source that's not about to go out of style in the future.

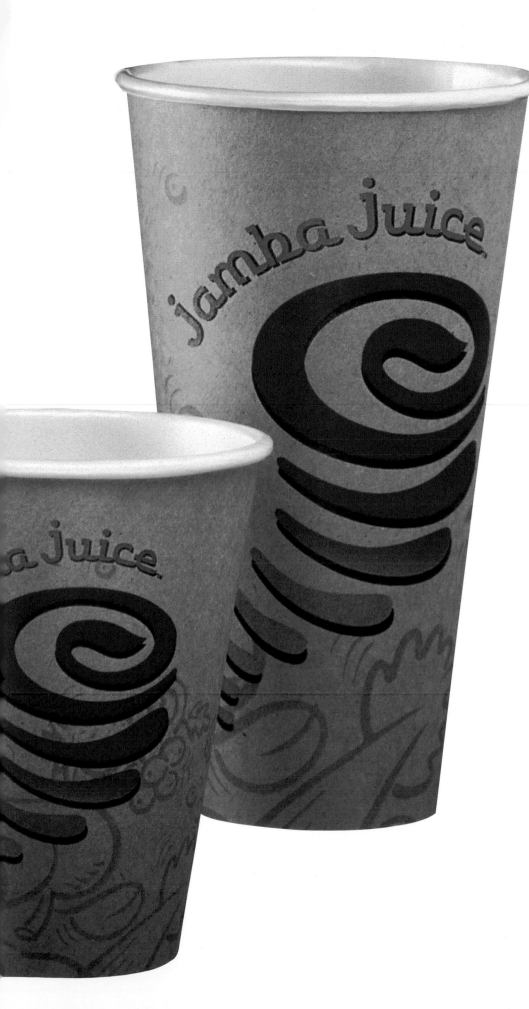

TIP

Always begin a design in black and white, to refine shapes before adding color. Color masks flaws in form. Since most logos will appear in black and white at some point in their use, it's better to spot weak points during the creative process than after implementation.

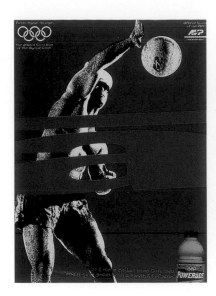

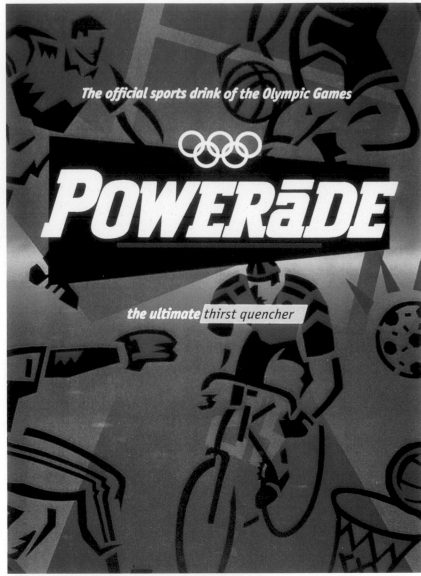

> CLIENT: Coca-Cola Company/Powerade
> Atlanta, Georgia
> DESIGN FIRM:
> Desgrippes Gobé & Associates
> New York, New York
> CREATIVE DIRECTOR: Joanna Felheim
> DESIGNERS: Francine Germano,
> Susan Berson

In direct competition with such other athletic drinks as Gatorade, the Coca-Cola Company developed Powerade, a beverage that aids in electrolyte replacement while quenching thirst. The Desgrippes Gobé design team created a powerful, masculine image that readily conveys the highly active lifestyles of its potential consumers using a bold, primary color palette and a fast-paced sans serif typeface.

The final design was applied to bottle labels and other packaging, collateral materials, 1996 Olympic sponsorship posters, T-shirts, and baseball caps, and it even appears on the face of sponsored beverage vending machines.

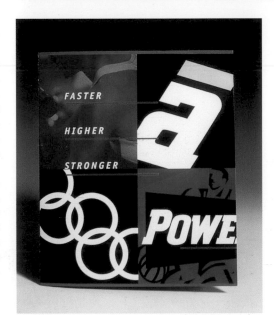

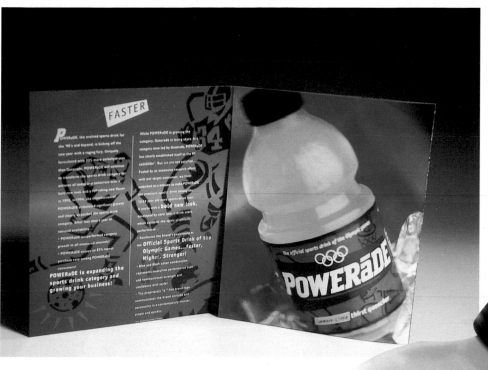

TIP

To test the shape of a design, turn it upside-down. This allows you to see it fresh and to spot hidden flaws.

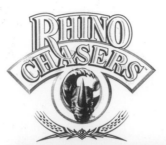

CLIENT: Rhino Chasers
Huntington Beach, California
DESIGN FIRM: Hornall Anderson
Design Works, Inc.
Seattle, Washington
ART DIRECTOR: Jack Anderson
DESIGNERS: Jack Anderson,
Larry Anderson, Bruce Branson-Meyer

This retail microbrewery needed a look that propelled its image above its numerous competitors when it was initially released to select markets in California and the East Coast. The name Rhino Chasers refers to the experienced surfers of the 1950s who surfed the big 50-foot (15-meter) waves (aka rhinos). The client's name implies that its members are a handful of free-spirited individuals who challenge extreme conditions to have the most fun possible. HADW developed the bold rhino head medallion to reflect that company attitude and chose a rich color palette of four hues to distinguish the four beer flavors.

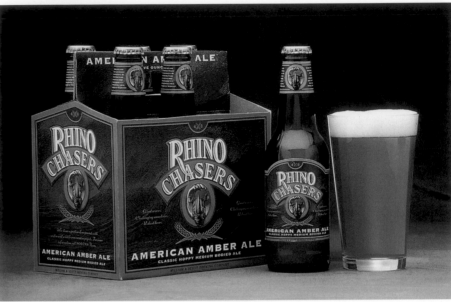

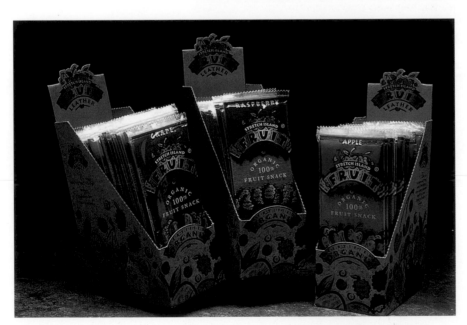

CLIENT: Stretch Island Fruit Leather
Grapeview, Washington
DESIGN FIRM: Hornall Anderson
Design Works, Inc.
Seattle, Washington
ART DIRECTOR: Jack Anderson
DESIGNERS: Jack Anderson,
Mary Hermes, Leo Raymundo

Creating an image that looked fun and attracted children while promoting its healthfulness to encourage parents and other adults to purchase the product was the challenge HADW faced when commissioned to create this family of fruit treats' identity program. The solution was to establish a bright, festive color palette, playful graphic interpretations of the different fruit flavors, and contemporary typographic treatments that could be applied to individual flavors through-out both the regular and organic product lines in the family.

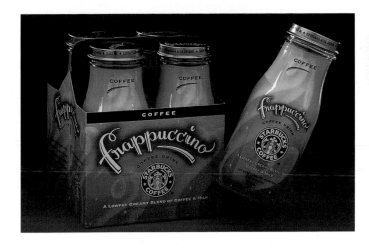

CLIENT: Starbucks
Seattle, Washington
DESIGN FIRM: Hornall Anderson
Design Works, Inc.
Seattle, Washington
ART DIRECTOR: Jack Anderson
DESIGNERS: Jack Anderson,
Julie Lock, Jana Nishi, Julie Keenan,
Mary Chin Hutchison, Julia LaPine

HADW's objective was to develop a
unique brand identity that appropriately
positioned Frappuccino in the retail
beverage marketplace. The four-pack
basket container and bottle graphics
depict the blending of this creamy milk
and coffee drink that comes in two
flavors. The main red, white, and green
color palette reflects the drink's Italian
origins, while subordinating hues clearly
identify each flavor.

CLIENT: Melhspeisen
Tokyo, Japan
DESIGN FIRM: Desgrippes Gobé & Associates
Tokyo, Japan

In German, this company's name—
Melhspeisen—means the "art of flour."
The Desgrippes Gobé design team was
commissioned to create a new identity for
this line of freshly baked goods that are sold
in Japan. Combining a touch of modernity
and sophistication with the product's
traditional German heritage, the new logo
features a Japanese baker and a German
meister exchanging recipes.

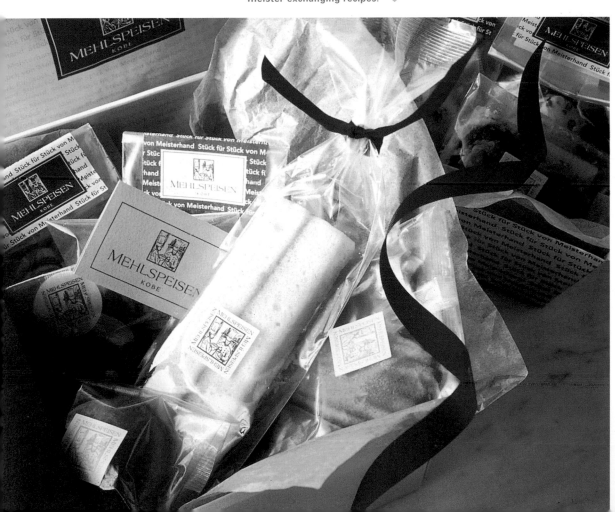

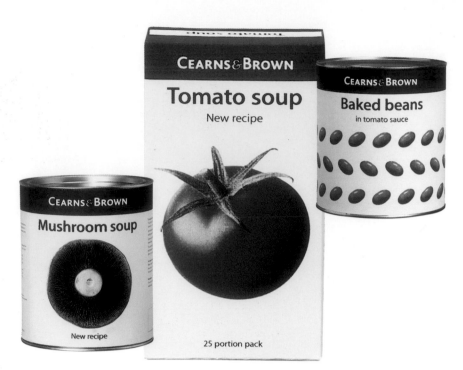

CLIENT: Cearns & Brown
Abingdon, Oxfordshire, United Kingdom
DESIGN FIRM: Wolff Olins
London, United Kingdom
CREATIVE DIRECTOR: Lee Coomber
DESIGNERS: Phil Rushton,
Kerry Humphreys, Sam Wilson
PHOTOGRAPHER: Mike Russell
ILLUSTRATOR: Pete Denmark
PRODUCTION: Roy Bowkett, Alan Coterell

Lewis Carroll, the author of Alice in Wonderland, seemed to be the inspiration behind another element in Wolff Olins' design solution. Instead of pondering "why the sea is boiling hot and whether pigs have wings," the team considered a few delightful and edible possibilities. They developed a series of humorous icons that continue the program's photographic theme. Colorful strawberries, digestive biscuits, and buds of garlic race along on cartoonish legs on the sides of the company's delivery vans, while flying bananas, pickles, and mixing spoons soar above. This eye-catching mechanism brands the firm's presence on the general public as the vans make deliveries throughout the country.

❯

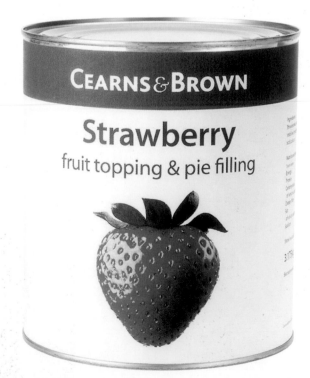

CLIENT: Cearns & Brown
Abingdon, Oxfordshire, United Kingdom
DESIGN FIRM: Wolff Olins
London, United Kingdom
CREATIVE DIRECTOR: Lee Coomber
DESIGNERS: Phil Rushton, Kerry Humphreys, Sam Wilson
PHOTOGRAPHER: Mike Russell
ILLUSTRATOR: Pete Denmark
PRODUCTION: Roy Bowkett, Alan Coterell

One of Great Britain's largest independent institutional food distributors—Cearns & Brown—decided to brand its name on the general public after 167 years of established existence. This family-owned business had been a member of the Countrywide Catering Distributors consortium that carried its own Country Range product line. The Wolff Olins design team found that the company's image had been completely absorbed into Countrywide's identity, and the end of that relationship meant that the company needed to develop a new identity. Despite the firm's individual reputation as an honest and respected supplier, the company had no visual brand. In other words, the design team had to start at "square one." The team took a fresh approach by employing a large dose of well-posited humor within a clean, uncluttered framework. The Cearns & Brown logotype—a proprietary typeface that was developed by Jeremy Tankard and based on an existing font called Bliss—and color palette—Pantone 343 green and high white—are at the heart of the revamped identity system that appears on the company's new packaging line, delivery vans, and promotional materials.

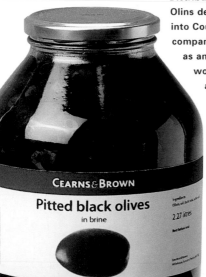

CEARNS & BROWN
Pitted black olives
in brine

CEARNS & BROWN
Tea
100 tagged tea bags

CEARNS & BROWN
Natural breadcrumbs

TIP

You've probably heard that form follows function. In logo design, this means that you can't create or judge a logo until you know what it's supposed to do. A logo is only effective if it represents that which it's meant to represent. Without accurate conveyance, it's worthless.

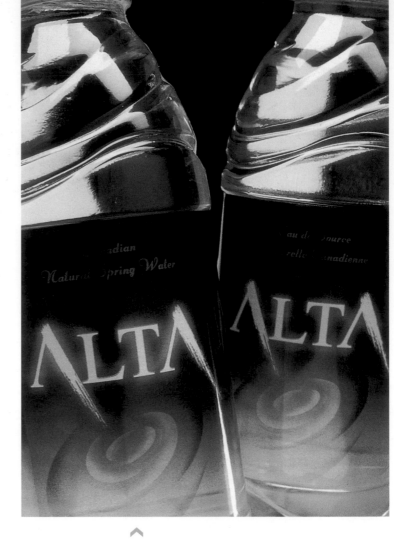

CLIENT: Alta Beverage Company
Sidney, British Columbia, Canada
DESIGN FIRM: Hornall Anderson Design Works, Inc.
Seattle, Washington
ART DIRECTOR: Jack Anderson
DESIGNERS: Jack Anderson, Larry Anderson,
Julie Keenan

This Canadian beverage company wanted a mark that would convey a strong sense of location and the qualities inherent in their pure, natural spring water. HADW focused its design theme on the arctic wind that blows through the snowy Canadian Rockies. With Times Roman as a typographic base, the mark developed a strong, classic feel with a spontaneous twist: The brushlike stroke was designed to emulate a glacial mountain. The ice-blue glow around the type added to the fresh, outdoor appearance.

CLIENT: Xcel
Sidney, British Columbia, Canada
DESIGN FIRM: Hornall Anderson Design Works, Inc.
Seattle, Washington
ART DIRECTOR: Jack Anderson
DESIGNERS: Jack Anderson, Larry Anderson, Julie Keenan

Xcel—a nutriceutical, isotonic drink for athletes—needed to reflect the rejuvenating and healthy effects of the beverage itself, which contains aloe vera as one of its main ingredients. HADW focused on the herb's origins: It was used by the ancient Greeks and Romans as a revitalizing and youth-enhancing tonic. The wing effect on the X references mercurial attributes such as speed, health, energy, vitality, and youth. The look and feel of Greco-Roman stone columns were reinforced by the use of in-line spaces within each letter, which were then smoothed out, making them more graceful.

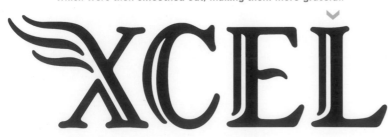

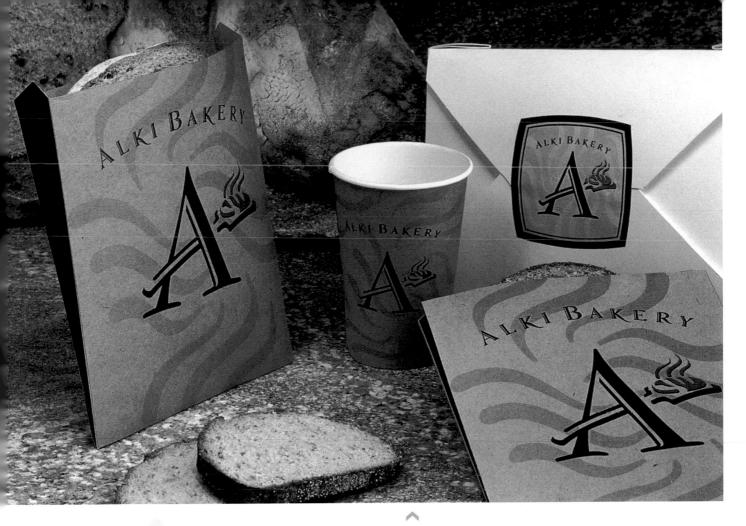

ALKI BAKERY

ALKI BAKER

CLIENT: Alki Bakery & Café
Seattle, Washington
DESIGN FIRM: Hornall Anderson Design Works, Inc.
Seattle, Washington
ART DIRECTOR: Jack Anderson
DESIGNERS: Jack Anderson, David Bates
ILLUSTRATOR: David Bates

Located right on Alki Beach in southwestern Seattle,
this busy bakery and café needed an identity that
would focus on the high-quality, home-style bread
products that are baked right on the premises and the
café's warm, neighborhood bakery atmosphere. Two
different logos were designed. One features an A as the
bakery's logo; the café's logo features a cartoonish
baker—the company's mascot. Both images were
applied to packaging, point-of-purchase materials, and
signage. Warm, full-bleed colors helped to brand the
product's upscale quality. To emphasize the client's
concern for the environment, packaging was printed
on recycled kraft paper.

CLIENT: C. W. Gourmet/ Mondéo Restaurants
Santa Clara, California
DESIGN FIRM: Hornall Anderson Design Works, Inc.
Seattle, Washington
ART DIRECTOR: Jack Anderson
DESIGNERS: Jack Anderson, David Bates, Sonja Max

This California restaurant chain features a specialty menu of innovative and exciting bowl and wrap meals made with an array of fresh ingredients. HADW's design portrays the fusion of a globe, a bowl, and wrap in motion, reflecting the restaurant's international selections, serving style, and fast service. The logotype continues this theme, calling to mind an earthy, old-world atmosphere.

CLIENT: Food Services of America
Seattle, Washington
DESIGN FIRM: Hornall Anderson Design Works, Inc.
Seattle, Washington
ART DIRECTOR: Jack Anderson
DESIGNER: Jack Anderson

A large, institutional food distributor to restaurants, schools, and hospitals, Food Services of America's "Circle of Stars" logo was designed for an employee-recognition program. The star symbol was chosen to represent the company's select group of contributors/members being honored for their work; it also references the corporate logo.

CIRCLE OF STARS

CLIENT: Best Cellars
New York, New York
DESIGN FIRM: Hornall Anderson
Design Works, Inc.
Seattle, Washington
ART DIRECTOR: Jack Anderson
DESIGNERS: Jack Anderson,
Lisa Cerveny, Jana Wilson

This wine distributor and reseller needed a series of icons to brand the eight different varieties it marketed. HADW developed a wine-stain icon. The shape defines the C of Cellars, and the typographic treatment of the B complements the roughness of the stain. Using the basic wine stain to support the identity, additional images were added to the subordinating icons: lips for "luscious," bubbles for "fizzy," cherries for "juicy," a lollipop for "sweet," a lemon wedge for "fresh," the sun for "big," water and the moon for "smooth," and clouds for "soft."

CLIENT: Danone, Paris, France
DESIGN FIRM: Landor Associates
San Francisco, California
(corporate office)

Danone is the leading food distributor
of dairy products, mineral water,
sauces, condiments, and glass con-
tainers in France, Italy, and Spain. When
this major international corporation
decided to work with Landor
Associates to revise its image from its
previously type-heavy presence, the
design team looked to the nighttime
skies for inspiration. Following the
recent trend for a lighter, warmer
approach to corporate identity, the
main visual feature is a child looking
up at a star.

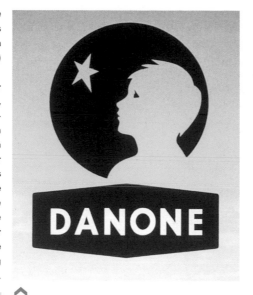

CLIENT: Capons Rotisserie Chicken
Seattle, Washington
DESIGN FIRM: Hornall Anderson
Design Works, Inc.
Seattle, Washington
ART DIRECTOR: Jack Anderson
DESIGNERS: Jack Anderson, David Bates

Focusing on the cooking style used
by this chain of rotisserie take-out
restaurants, HADW's design solution
reflects the warmth of a small neighbor-
hood take-out restaurant: a strong
contrast to its more commercial fast-
food competitors. The spinning tornado
motif incorporated in the chicken's body
reinforces both concepts: the rotisserie-
style cooking method and the speed
of fast food from order to delivery.

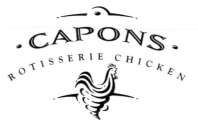

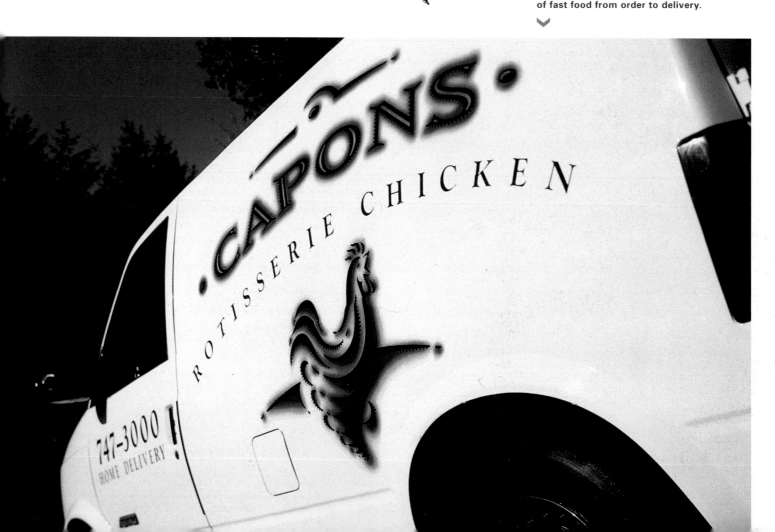

CHAPTER

housewares
and
real estate

nearly everyone wants to live in a warm, comfortable home, surrounded by pleasant furnishings that reflect their own personal tastes and habits. Housewares and real estate businesses offer consumers essential choices such as ''We can provide you with comfort'' or ''We will help you find a safe place to live, work, or shop'' or ''We'll help you create your dream castle.'' Your design solutions for these types of establishments must convey a familiar sense of style, whether it's classic, contemporary, country, or industrial chic. It must convince consumers that they will find items that complement their lifestyles. It must promise them that visitors to their homes or workplaces will know who they are by their possessions and living space. It must guarantee that these possessions are made to last.

Home furnishings and accessories have evolved into extensions of our perceived self-images. The selection and positioning of a table or chair can be just as critical as deciding what outfit to wear. Businesses that provide these stylish essentials have to answer the needs of a diverse audience, so their brand identity needs to rely on the sturdiness of its name and the almost timeless appeal of its visual presence.

Ethan Allen has been a well-established purveyor and manufacturer of fine home furnishings and accessories for more than sixty years. The

**CLIENT: Ethan Allen Danbury, Connecticut
DESIGN FIRM:
Desgrippes Gobé & Associates
New York, New York
CREATIVE DIRECTOR:
Marc Gobé
DESIGNER: Melinda Beck**

The updated Ethan Allen is further branded on shopping bags, shipping cartons, and truck signage, as well as printed catalogues, corporate manuals, and their Website.

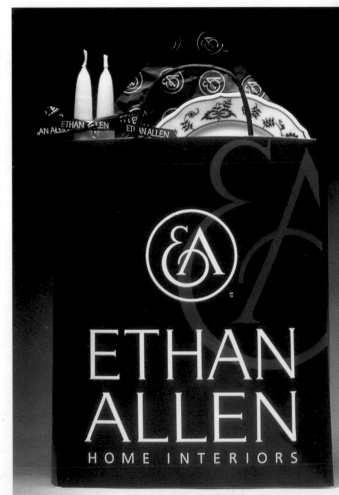

ETHAN ALLEN HOME INTERIORS

ETHAN ALLEN

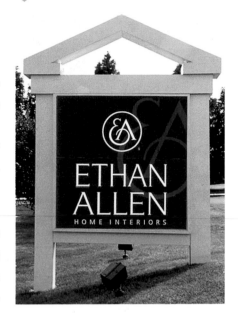

company had outgrown its original well-branded image as a source for high-quality classic colonial and country-style wood furniture. The company has expanded its repertoire to include accessories such as candlesticks, tablesettings, floor coverings, and wall hangings. It also has added modern and contemporary furniture styles offered in a price range that is affordable to a growing market segment: young couples who want to invest in well-made, long-lasting furniture.

The company, located in Danbury, Connecticut, commissioned Desgrippes Gobé's New York office to develop a revitalized image program for the parent firm and its nationwide retail store chain. The design team identified an all-encompassing, stylish approach that would appeal to both young and upscale market segments. The entire visual identity concentrated on the company's name and its reputation as a respected New England furniture manufacturer. The strategy included making a radical departure from an original green-and-brown color palette by adopting a more upbeat medium blue and white scheme that would attract a more nationalized consumer base.

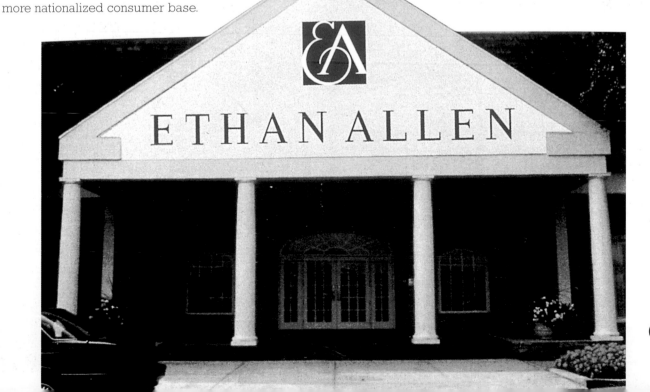

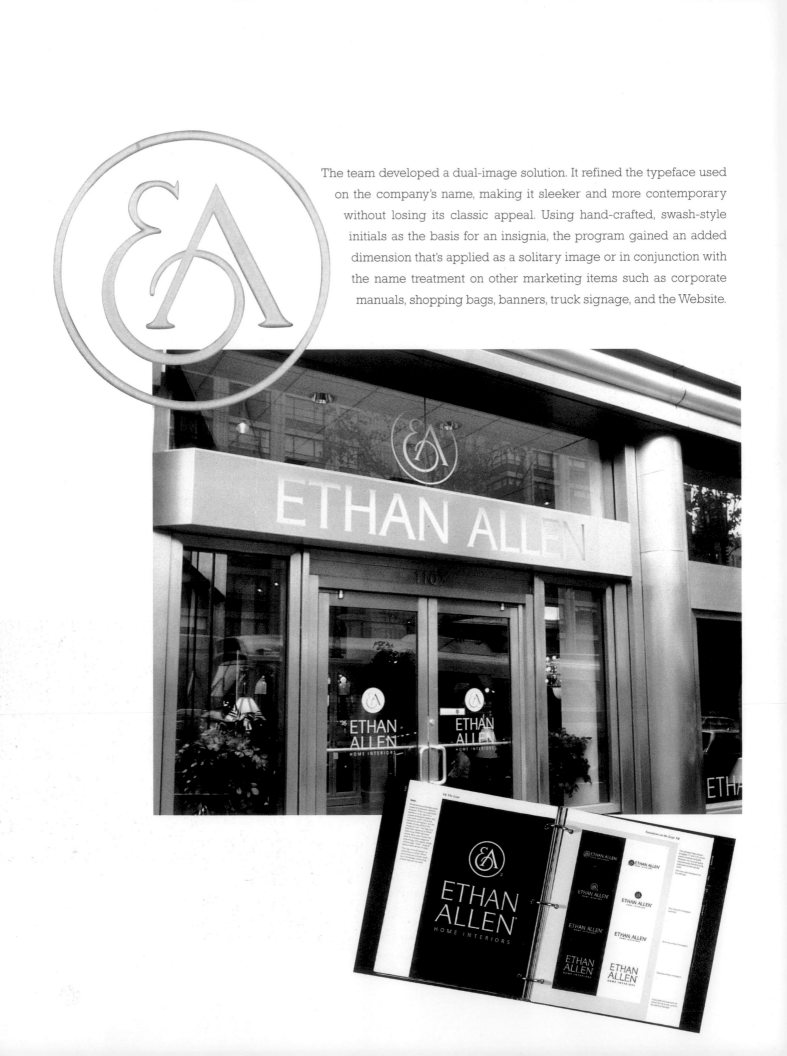

The team developed a dual-image solution. It refined the typeface used on the company's name, making it sleeker and more contemporary without losing its classic appeal. Using hand-crafted, swash-style initials as the basis for an insignia, the program gained an added dimension that's applied as a solitary image or in conjunction with the name treatment on other marketing items such as corporate manuals, shopping bags, banners, truck signage, and the Website.

Because the retail stores are located in both urban and suburban settings, the identity program had to accommodate a number of different signage applications from the name mounted on the facade to insignias printed on exterior awnings and from stand-alone roadside plaques to eye-level entry signs.

Creating a visual point of difference—a distinct element that makes an identity unique—doesn't always have to find its foundation in a specific trend or style. Sometimes, effective individuality is best constructed by applying an almost invisible or universal appearance that focuses its attention on originality and strong, clear communication. This is especially important when you're trying to address a broad audience and your message clearly states that you can be all things for all people.

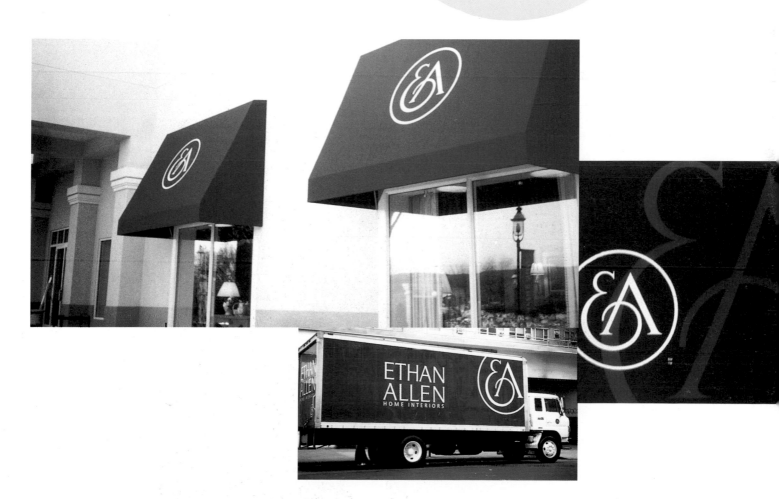

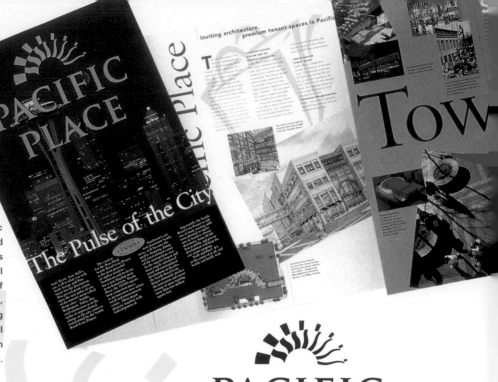

CLIENT: Pacific Place
Seattle, Washington
DESIGN FIRM: Hornall Anderson
Design Works, Inc.
Seattle, Washington
ART DIRECTOR: Jack Anderson
DESIGNERS: Jack Anderson, Heidi Favour,
David Bates

Under construction in downtown Seattle, Pacific Place is an innovative, five-story, urban retail and entertainment center whose design revolves around a large, curved skylight in the central atrium. HADW concentrated on the concept of bringing the outdoors inside in its design solution, which was applied to a newsletter, mailing envelopes, and presentation folders. The overall message reflects a feeling of light and energy in this potentially active retail environment.

PACIFIC PLACE

UNIVERSITY VILLAGE

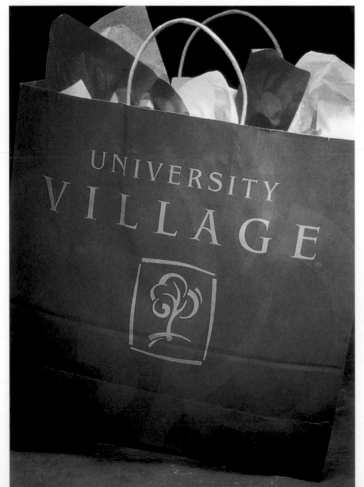

CLIENT: University Village
Seattle, Washington
DESIGN FIRM: Hornall Anderson
Design Works, Inc.
Seattle, Washington
ART DIRECTOR: Jack Anderson
DESIGNERS: Jack Anderson, Cliff Chung

The University Village—an open-air retail store complex—needed an updated umbrella identity that incorporated its previous icon (a tree) but emphasized its recent expansion, which included the addition of a village square. HADW blended these two images together and chose an upscale color palette to convey the message of growth and diversity with concentration on quality.

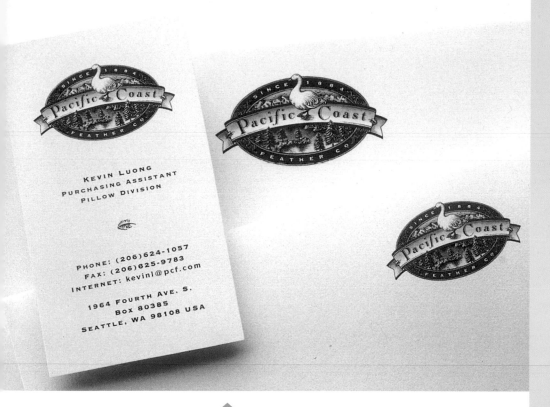

KEVIN LUONG
PURCHASING ASSISTANT
PILLOW DIVISION

PHONE: (206)624-1057
FAX: (206)625-9783
INTERNET: kevinl@pcf.com

1964 FOURTH AVE. S.
Box 80385
SEATTLE, WA 98108 USA

CLIENT: Pacific Coast Feather Company
Seattle, Washington
DESIGN FIRM: Hornall Anderson Design Works, Inc.
Seattle, Washington
ART DIRECTOR: Jack Anderson
DESIGNERS: Jack Anderson, Julie Lock, Heidi Favour,
Leo Raymundo

This premier manufacturer of pillows and down comforters chose to introduce a warmer appearance as the focus of its point of difference. HADW emphasized Pacific Coast's long-established presence in the Northwest by using a warm color palette and illustration of mountains, trees, and water. (The goose and oval outline were retained from the previous logo design.) The revised identity was applied to the client's letterhead, products, and marketing materials.

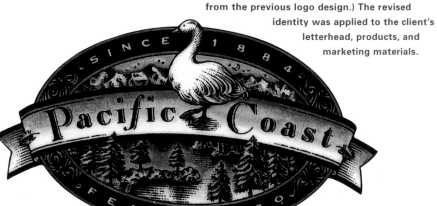

IT'S ELEMENTARY

The logical approach to logo design is the same as the generation of a solution to any problem. First, identify the need; figure out what you want to represent visually. Second, brainstorm solutions (don't reject anything at this point). After you've generated a pile of ideas, sort them into "hot," "maybe," and "what the heck was I thinking." Set the other two piles aside, and sift through the "hot" pile. See if there are better solutions to be found by combining elements from different ideas. Narrow it down to three or four; then sift through the other two piles again to see if any new thoughts present themselves. If any do, then eliminate as many as you have to, keeping the number of main possibilities down to three or four. Take these and test them. Get to know them. Then present them to the client.

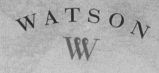

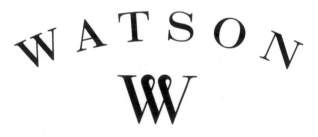

WATSON

CLIENT: Watson Furniture Company
Bainbridge Island, Washington
DESIGN FIRM: Hornall Anderson
Design Works, Inc.
Seattle, Washington
ART DIRECTOR: Jack Anderson
DESIGNERS: Jack Anderson,
Mary Hermes, Leo Raymundo

This thirty-year-old commercial/custom furniture manufacturer changed its business focus from manufacturer of traditional workstations to provider of ergonomic solutions with flexible workstations. HADW's design solution incorporated the client's ergonomic niche by using a fluid *W*—symbolizing a solid structure that intersects with fluid, flexible movement—in addition to the company name.

To be simple is to be great.

—*Ralph Waldo Emerson*

CLIENT: Taisei Corporation
Tokyo, Japan
DESIGN FIRM: Landor Associates
San Francisco, California (corporate office)

This leading Japanese architecture, engineering,
and construction firm not only works on
commissioned buildings but also develops and
finances its own projects. The company's logo
conveys an upbeat message: "Taisei builds solid
structures for a lively world."

To create an image
capable of growing
with a company, it's
important to understand
where that company is
headed and where it's
been. Read as much as
you can about your
client's business.

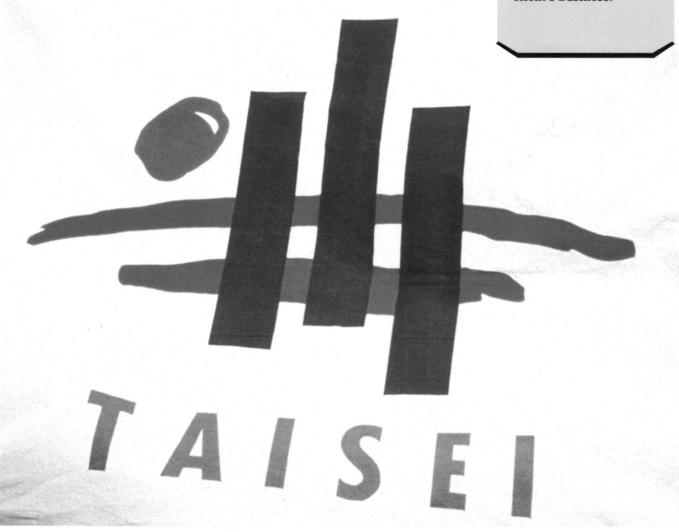

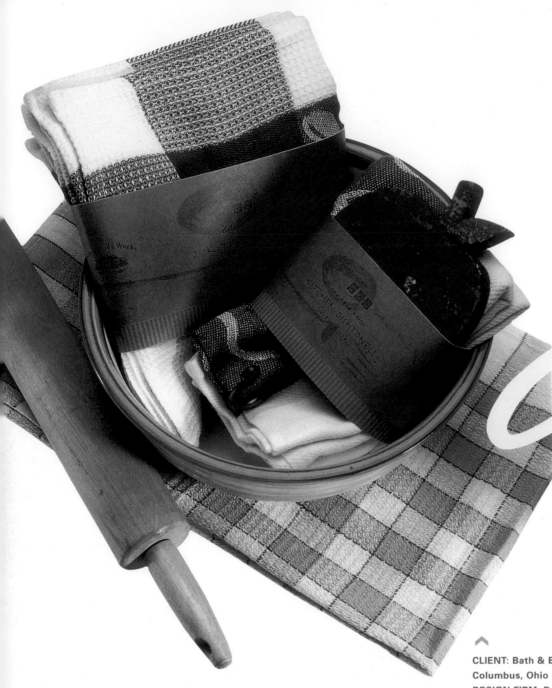

Bath & Body Works

at home

CLIENT: **Bath & Body Works at Home**
Columbus, Ohio
DESIGN FIRM: **Desgrippes Gobé & Associates**
New York, New York
DESIGN DIRECTOR: **Susan Berson**

The objective was to create a line of home products for the Bath & Body Works retail chain that would echo the heritage of the brand—"From the Heartland"—while differentiating the new line from the existing body-care products. Desgrippes Gobé designed fresh, gingham-patterned labels overlaid with handwritten type, giving a lighthearted country feel. The logo features a country house that visually reinforces the brand's American heartland positioning.

home

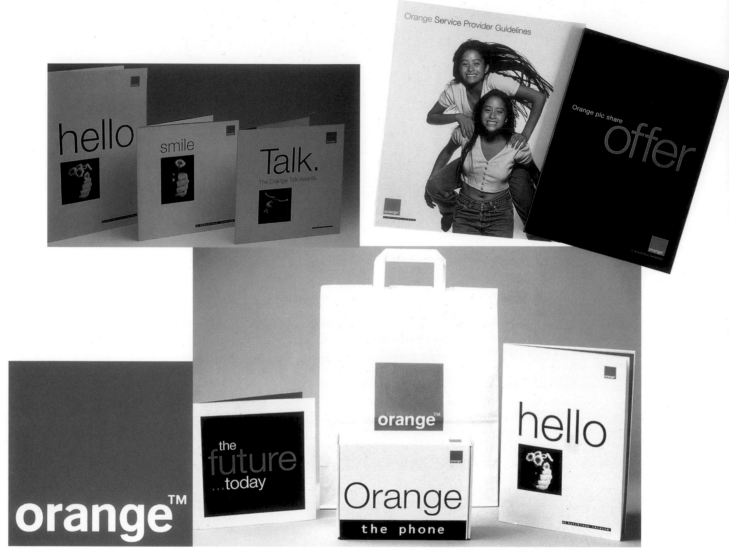

CLIENT: **Orange**
London, United Kingdom
DESIGN FIRM: **Wolff Olins**
London, United Kingdom
EXECUTIVE CREATIVE DIRECTOR:
Douglas Hamilton
CREATIVE DIRECTOR: **Robbie Laughton**
PROJECT MANAGER: **Keith Kirby**
DESIGNERS: **Daren Cook, Martin Brown**
PRODUCTION: **Roy Bowlett**

The national digital wireless phone service
that provides more than 92 percent of Great
Britain's phone service is tailored for a
consumer-based market. The Wolff Olins
design team focused the company's name,
color palette (orange, black, and white), and
sans serif typeface to clearly spell out the
company's approach to business: direct and
to the point.

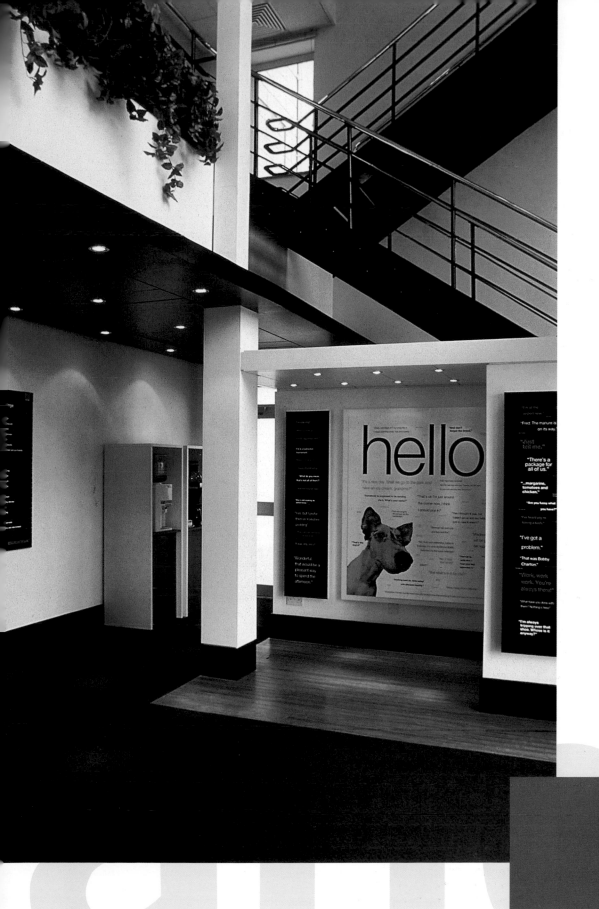

orange™

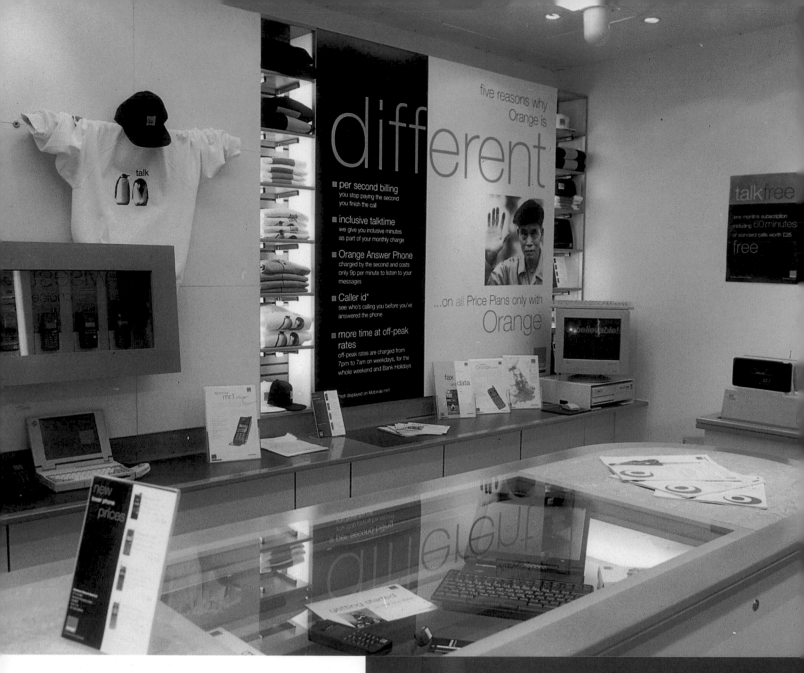

five reasons why Orange is

diff**erent**

■ **per second billing**
you stop paying the second you finish the call

■ **inclusive talktime**
we give you inclusive minutes as part of your monthly charge

■ **Orange Answer Phone**
charged by the second and costs only 9p per minute to listen to your messages

■ **Caller id***
see who's calling you before you've answered the phone

■ **more time at off-peak rates**
off-peak rates are charged from 7pm to 7am on weekdays, for the whole weekend and Bank Holidays

...on all Price Plans only with

Orange

talkfree

fax and data

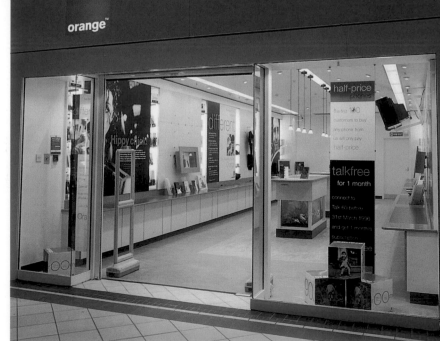

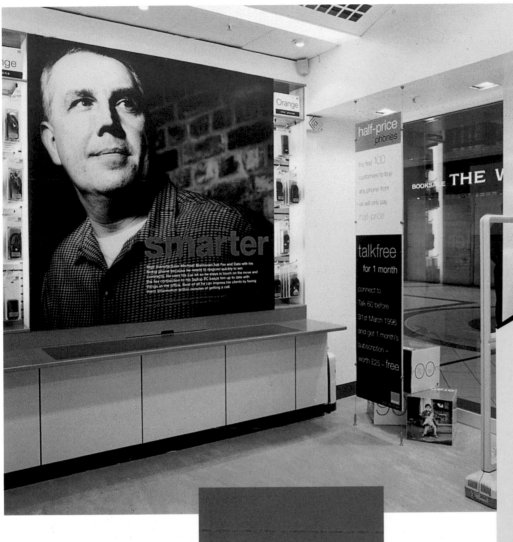

orange™

TIP

Creativity is the art
of seeing that there are
limitless possibilities.
A single-letter logo?
For a non-creative
person, that's just one
letter to play with.
For a creative person,
it's a primed canvas
waiting for the
application of any
one of thousands of
potential typefaces—
and those are just the
ones that have already
been invented.

transportation and travel

CHAPTER 3

life in the twentieth century has pressed consumers to seek the fulfillment of yet another basic human need: transport. Finding a convenient way to move oneself from one point to another has accelerated well beyond purchasing a healthy horse or booking passage on a transoceanic vessel. Successful automotive, shipping, and travel identities establish promises. Efficiency, speed, safety, and personal pleasure have become part of the anticipated relationship between customer and transport provider. But how you do convey statements such as "We will comfortably transport you and your goods to your selected destination" or "We will make you feel safe along your journey" or "You will gain freedom and individuality when you drive this vehicle" within the confines of a logo? Your design solution for transportation, shipping, and travel clients must promise motion. It has to convince consumers that they—or their passengers or packages—will arrive where they want to go in the manner, speed, and style they desire.

The 1970s marked a reality check for American car buyers, designers, and manufacturers. Oil prices shot up, and environmental concerns began to take precedence over the comfort and power that had been primary selling points almost since the industry's birth at the beginning of the century. American car designs rapidly shrank to compete with foreign compact car competitors. Automotive designers focused on utilitarian solutions, cutting aesthetics to emphasize economy. But consumers weren't buying the change. Although manufacturers produced a line of efficient cars that were a welcome change from the vehicles of the early 1970s, these new designs proved to be uninspired. Their names and symbols quickly were paired with unattractive concepts like "family car," "tank," and "gas guzzler."

CLIENT: Chrysler Corporation
Auburn Hills, Michigan
DESIGN FIRM: In-house

Originally created for the 1924 model year, the distinctive Chrysler Gold Badge and Silver Wings served as hallmarks of the American automotive industry until Chrysler retired them in 1957. Forty years later they have returned, merged into a single logo for the first time, replacing the now-familiar Chrysler star logo on the grilles of the automaker's entire line of cars. The new logo is clearly suited to the sleek and graceful design of the cars themselves.

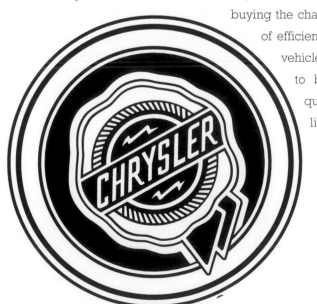

American manufacturers searched for ways to entice consumers back into the domestic automotive fold during the 1980s, but Japanese and European automakers had taken a large share of the consumer market by applying a highly effective strategy. Mercedes-Benz, Rolls Royce, and Nissan had built their brands by positioning both their names and symbols with concepts like "quality," "efficient comfort," and "style."

Consumers often purchase a particular vehicle because the name, the icon, and the design fulfill their self-image and are packaged in their price range.

Rarely do consumers buy a car simply because it will be the most cost-effective means of transport. It wasn't until the 1990s that American automotive designers shed the straight lines and hard angles—hallmarks of car design for nearly two decades. They developed new interpretations of the highly organic, aerodynamic shapes that had been so popular during the 1930s and 1940s. It is a refreshing change that has successfully caught the imaginations of American consumers and convinced many to purchase this latest collection of domestic models.

No major car company has grasped this trend better than the Chrysler Corporation. As of 1995, the oldest continually produced model in the Chrysler line was only five years old. Manufacturers generally rely on the branding of existing logos and model names to lead consumers from one model year to the next. However, in a move that could only serve to emphasize the company's complete break with the recent past, Chrysler reinstated a logo that hadn't been seen for nearly four decades.

The distinctive silver wings first perched atop the 1924 Chrysler Six's radiator cap, accompanied by a gold Chrysler Seal on the radiator shell; this combination made its debut at the Hotel Commodore during the 1924 New York Auto Show. In the years that followed, the winged radiator cap was clearly visible on all Chrysler models. From 1931 to 1934, an exquisitely sculpted flying gazelle leaped up from behind the wings. The 1934 Chrysler Airflow not only featured the hood-mounted wings but also had rear fender shields decorated with a winged ornament. Chrysler continued to use hood ornaments until 1951, when a bolder redesign that cradled a circular wing was used to celebrate the launch of a new V-8 engine. Unfortunately, the wings were replaced in 1957 by a five-point star—the pentastar—after the public's taste shifted away from hood ornaments.

When Chrysler introduced its new, sleek line of passenger cars in 1995, the company felt that a new brand identity—drawn from the same sources as the vehicle designs themselves—

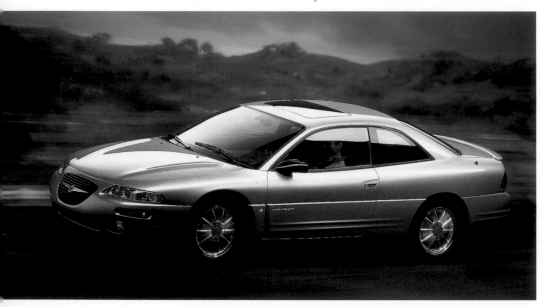

should accompany a revitalized market strategy. The gold Chrysler Seal was reinstated on the latest model, the Cirrus. In 1997, the company reintroduced the silver wings—merging them with the gold badge into a single logo for the first time—on the Sebring convertible, Concorde, Cirrus, and LHS models as well. The elements may be drawn from the 1920s, but the resulting insignia will remain very timely far into the next millennium as it is applied not only to the vehicles themselves but also prominently positioned in print and broadcast advertising and Internet marketing sites.

Although only time, high standards, and a consistent product can instill intrinsic value into a symbol, identities with equal visual strength can be created. This becomes more apparent when the Chrysler logo is broken down into its components, and these are examined.

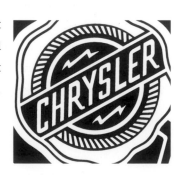

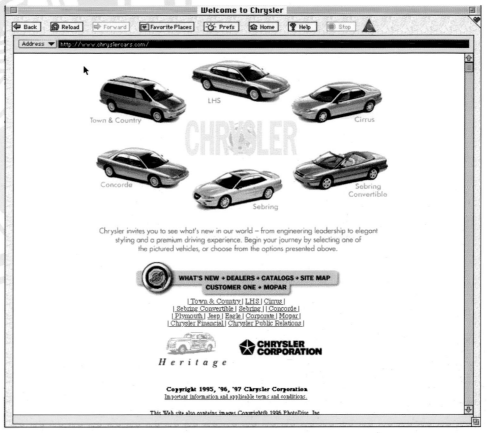

Wings represent both speed and freedom—two things consumers associate with a car. A mustang, an arrow, an impala, other animals, and a host of abstract symbols also have been employed to represent these same ideals on other vehicle makes and models. The blue-ribbon badge is an amalgam of an official seal, like those used to signify the legitimacy of a document, and a first prize ribbon. The medium and method of choice—chrome, gold-toned metal or high-impact plastic, deeply embedded colors, and a clear-coat finish—were equally important. This may seem obvious, but remember, various automotive designers have experimented with other media—paint, decals, and softer plastics—to create new logos. The primary downfall of these attempts was their durability—how could a faded, chipped, or peeling logo claim that the product it represents is safe and reliable, much less attractive and exciting. The slight increase in manufacturing cost can show an exponential return in a case like this.

While many of the best known, long-standing companies in the United States have gone through evolutions in their identities over the decades, Chrysler is one of a very few that have early brandings that are strong enough and refined enough to reintroduce to a whole new audience. The bottom line here is that good design is truly timeless. This is where an old trademark proves its continued asset value.

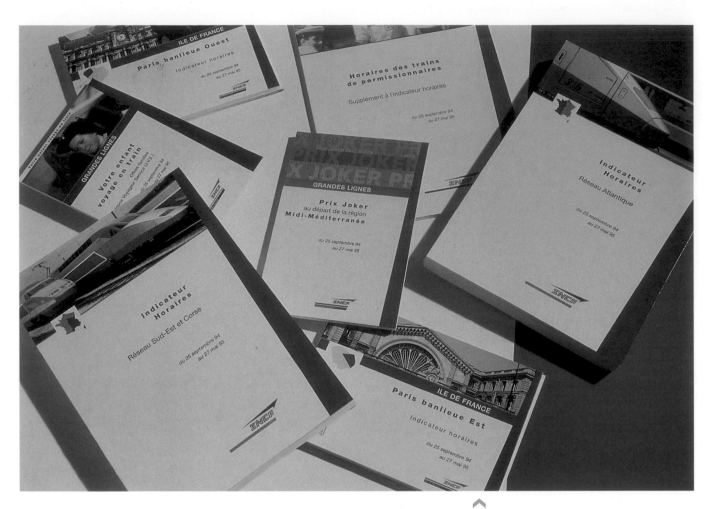

CLIENT: SNCF
Paris, France
DESIGN FIRM: Desgrippes Gobé & Associates
Paris, France
CREATIVE DIRECTOR: Alan Dor
PRESIDENT & CEO: Joel Desgrippes

The French national railway—SNCF—wanted
to refresh its established identity to reflect
the values and ambitions of this evolving
public-service transportation company's many
divisions and activities. The final Desgrippes
Gobé design solution preserved the existing
logo but added new elements that updated
the look, adding energy (blue communicates
safety while red symbolizes speed).

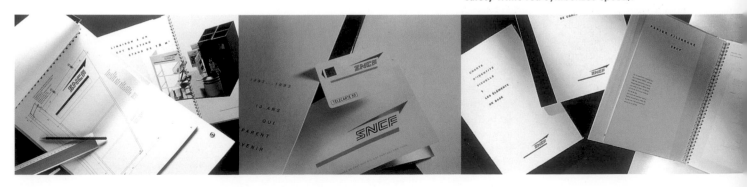

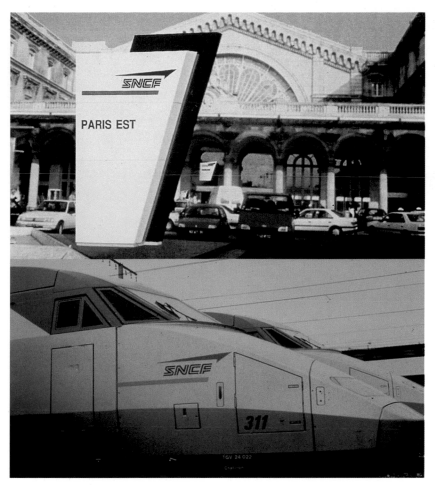

Réservez-vous le droit de voyager moins cher.

Places Joker
Des prix pour tous

The completed identity program was applied to stationery, consumer and marketing collaterals, railway station interiors and facades, and the railcars themselves, as well as the print advertising campaign.

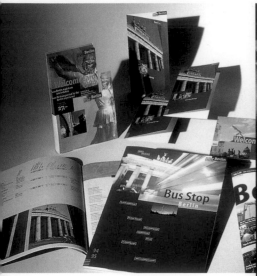
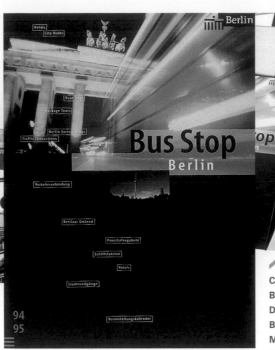

CLIENT: Berlin Tourism Marketing
Berlin, Germany
DESIGN FIRM: MetaDesign
Berlin, Germany
MANAGING DIRECTORS: Uli Mayer,
Erik Spiekermann
DESIGNERS: Pia Betton, Lucas de Groot,
Friedhelm Steinen-Broo, Priska Wollein

TIP

Get opinions. A logo is a visual representative. Its purpose is to communicate. While it may speak to you, unless you're the entire target market, it's important to find out if it'll speak to other people as well.

The client brief was simple: Design a new logo for the future that allowed only positive associations and express the dynamic development of the city of Berlin. In response, the MetaDesign team developed an abstract version of the landmark Brandenburg Gate and added the town's name in a proprietary typeface known as Meta. The final solution was applied to Berlin Tourism Board ads, folders, a magazine, a cover for a newsletter, a booklet with vouchers for tourists, and a brochure dispenser.

Simplicity is an exact medium between too little and too much.

—Sir Joshua Reynolds

When Chrysler introduced its new line of 1995 passenger cars, it also introduced a refreshing new identity for the company as well. The elements used in the gold Chrysler seal and the recently unveiled Chrysler wings logos originally appeared on the automaker's 1924 car models. This may seem like an extreme economy move to some, but applying these well-branded elements is an effective way to remind the public of this company's original mission: to build high-quality, stylish, aerodynamically efficient cars. It's also a great way to show the public that Chrysler's gone back to its early design roots. If your client's been around for a long time, you shouldn't be afraid to delve into the past for visual resources. You might find some important messages in a previous logo—an essential mission statement, a visual foundation—that could be incorporated into the client's current business approach. Or you might discover an image that's so strong that you only need to update the typographic treatment. The right inspiration for a logo design can come from current or past sources. Keep your eyes and your mind open while you're doing preliminary research.

CLIENT: Thomas Stewart
Seattle, Washington
DESIGN FIRM: Hornall Anderson Design Works, Inc.
Seattle, Washington
ART DIRECTOR: Jack Anderson
DESIGNERS: Jack Anderson, Nicole Bloss
ILLUSTRATORS: Jack Anderson, Nicole Bloss

This logo was designed for a personal yacht. The *M* stands for *Monteath*—the name of the boat and the boatowner's wife. The basic composition reflects the shape and points of a compass used in navigation. The flourish elements are reminiscent of water, waves, and the sea.

CLIENT: Audi
Germany
DESIGN FIRM: MetaDesign
Berlin, Germany
CREATIVE DIRECTOR: Pia Betton
PROJECT COORDINATOR: Michel Gabriel
DESIGNERS: Claudia Drecksträter,
Thomas Klein, Nadja Lorenzi, Anke Martini

The Audi name has been around since 1908, when August Horch first developed a solution to the problem of aerodynamic drag in the design of racecar bodies. Over the years, the brand has acquired a strong reputation for manufacturing a high-quality line of passenger vehicles. When the company chose to rename it major product ranges and launched the Audi A8, A6, and A4 models, a new logotype and treatment accompanied the sleek, new shapes and the supporting promotional materials.

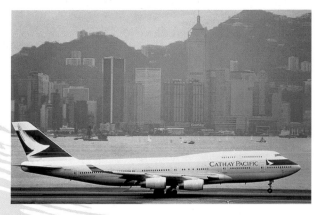

CLIENT: Cathay Pacific
Hong Kong, People's Republic of China
DESIGN FIRM: Landor Associates
San Francisco, California (corporate office)

When Cathay Pacific asked Landor Associates to create an identity that would convey the airline's Hong Kong roots, service, professionalism, and technological advancement, the result was a single gesture: a calligraphic "brushwing" icon. The company's signature green color palette was deepened and accented with touches of red (two colors that favor fortune and luck in the Chinese culture). The new identity was applied to livery, aircraft interiors, signage, ticket counters, stationery, and boarding passes.

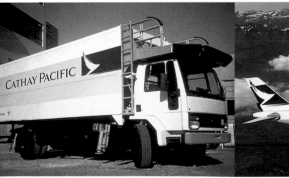

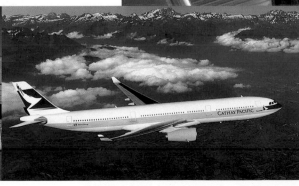

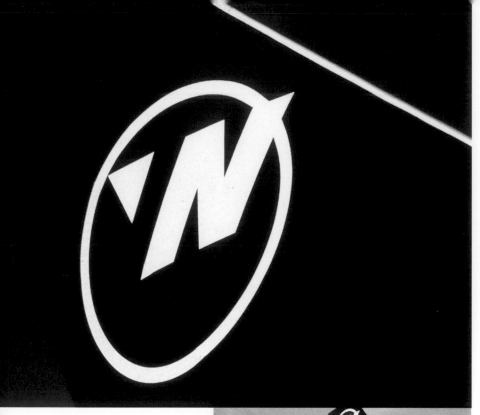

TIP

Don't be afraid to use elements you've seen applied in other people's work. Many of today's great designs have their roots in yesterday's great designs. This is no coincidence. Originality comes as much from reinterpretation and reinvention as it does from new beginnings.

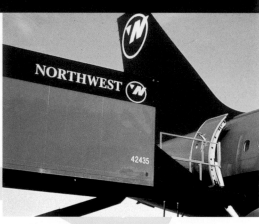

CLIENT: Northwest Airlines
Minneapolis-St. Paul, Minnesota
DESIGN FIRM: Landor Associates
San Francisco, California
(corporate office)

Concentrating on the airline's signature red-and-gray color palette, the Landor design team created this sleek, modern update for this established U.S. airline.

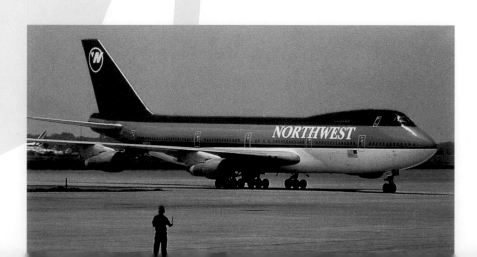

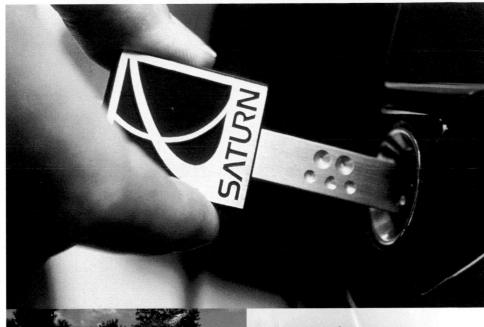

CLIENT: Saturn Corporation
Spring Hill, Tennessee
DESIGN FIRM: Landor Associates
San Francisco, California
(corporate office)

The Saturn symbol is a stylized rendition of the ringed planet, creating a metaphor that links the name of this separate General Motors car line and a quickly recognizable icon. The bold red palette and the modified NASA typeface further reinforce the power and speed the manufacturer wanted identified with the car itself. The finished solution was applied to marketing tools such as factory hard hats, T-shirts, and the keys issued with each vehicle.

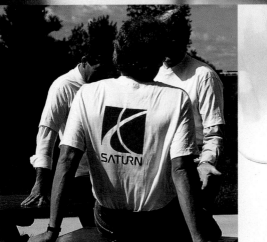

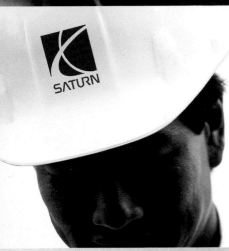

SATURN

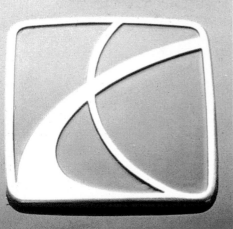

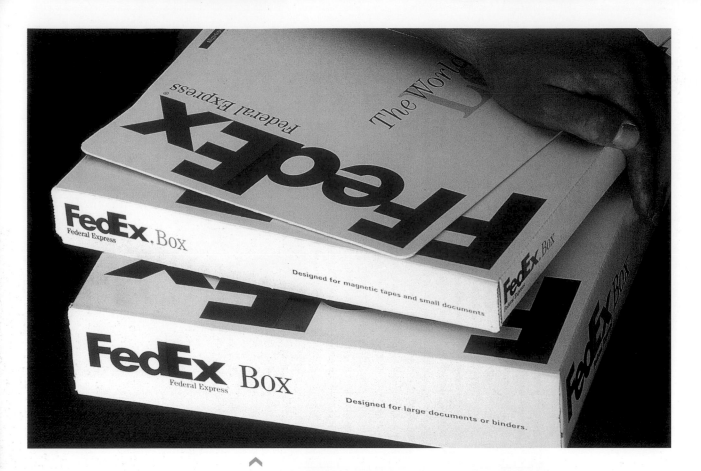

CLIENT: Federal Express
Memphis, Tennessee
DESIGN FIRM: Landor Associates
San Francisco, California (corporate office)

Federal Express revolutionized the way
companies ship packages in the early
1970s. Not many company names ever
become active verbs that are universally
understood by the general public, but the
FedEx name has grown into a brand with
just that type of recognition. To accompany
this identity refinement, Landor added the
tagline "The World on Time" to reinforce
the company's global and punctual
mission statement.

The World On Time

FedEx

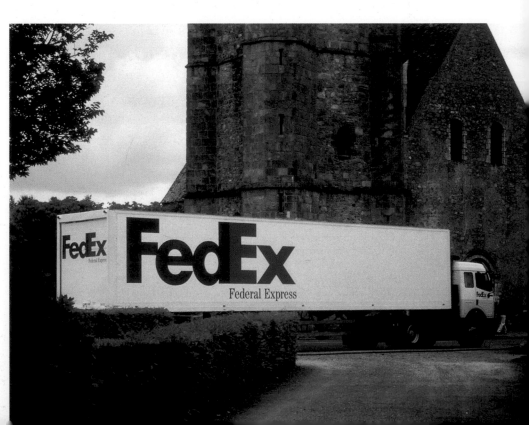

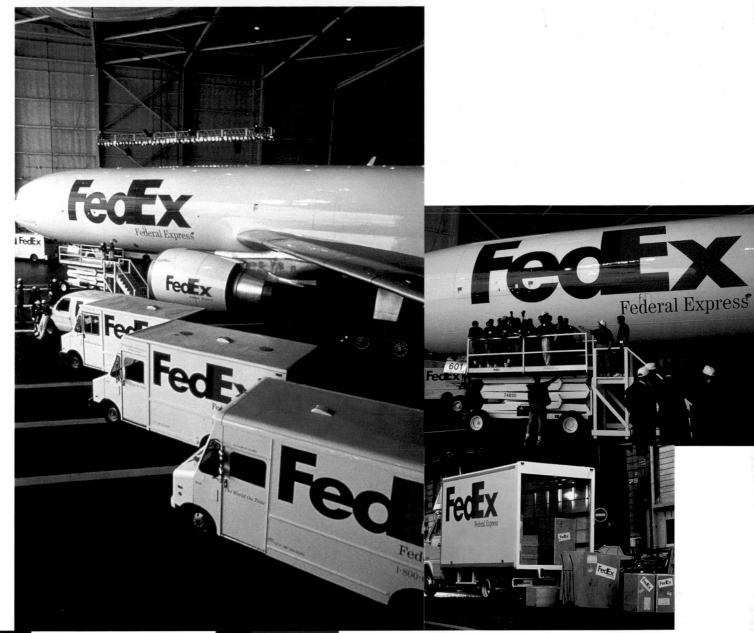

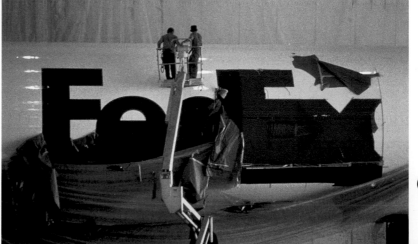

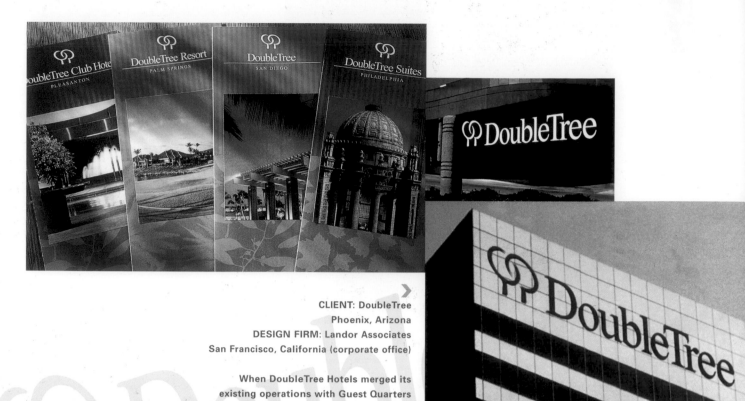

CLIENT: DoubleTree
Phoenix, Arizona
DESIGN FIRM: Landor Associates
San Francisco, California (corporate office)

When DoubleTree Hotels merged its existing operations with Guest Quarters Suites, the company hired Landor to develop a new identity that would reflect the change but maintain its reputation for friendly, personal service. A pair of modern, stylized, interlocking trees was the solution.

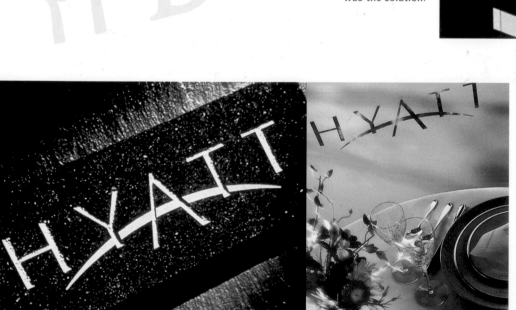

CLIENT: Hyatt Hotels
Chicago, Illinois
DESIGN FIRM: Landor Associates
San Francisco, California
(corporate office)

Rapid expansion of a company's physical interests often can wreak havoc on the firm's visual umbrella. Such was the case with this world leader in hospitality. Landor revitalized the hotel chain's image by unifying its many divisions under a single modernized identity that uses a crescent metaphor—symbolizing sunrise and sunset—as its hook.

LG Group

CLIENT: LG Group
Seoul, South Korea
DESIGN FIRM: Landor Associates
San Francisco, California
(corporate office)

The identity for this South Korea-based
industrial conglomerate focuses on a
highly stylized human face made up of
the company's initials, conveying the
message that even though industry is a
large concern, it still believes in its
people and its customers.

CLIENT: Caltex
Singapore
DESIGN FIRM: Landor Associates
San Francisco, California
(corporate office)

This major Singapore-based petroleum
retailer chose an effective yet simple
emblem—a star contained within a
circle. The color palette centers on
two colors that are considered to
attract fortune and success in
Asian cultures: dark green and red.

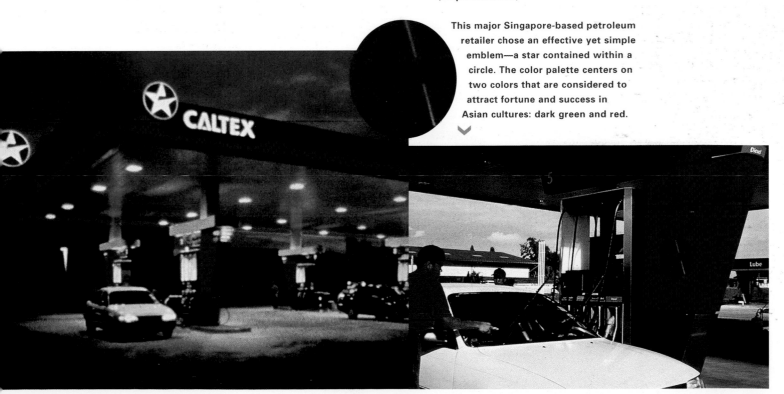

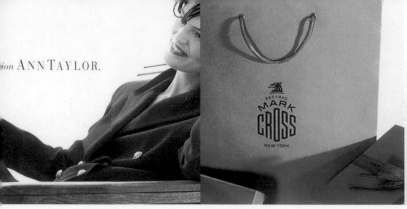

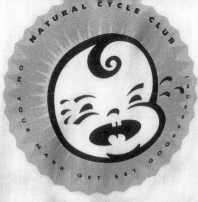

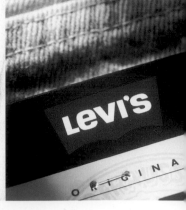

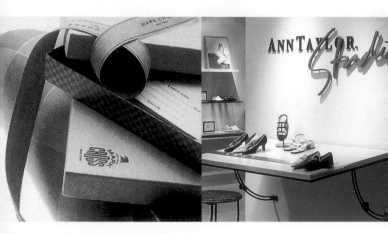

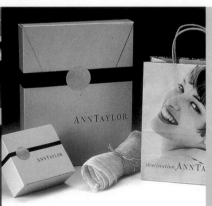

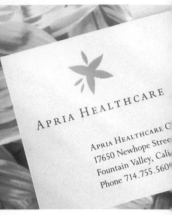

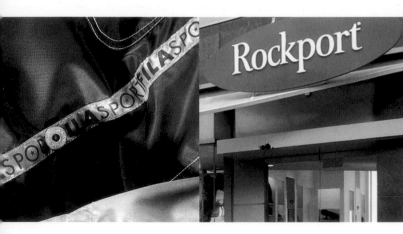

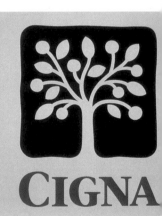

creating a memorable first impression

Ⓒreating a great first impression is the ultimate goal when you design identities, whether those identities are for sports equipment manufacturers, fitness centers, resorts, activity centers, or the fashion and cosmetics industries. You should set your sights on sculpting an alluring visual form that is not bashful when it chimes: "Here I am! I can make your dreams come true."

Consumers are much like actors: Great actors create a character by dressing and moving in a particular style. They work at this feat before they even enter the spotlight, choosing clothes, cosmetics, and even fitness regimens to shape the body. The same applies to the average consumer. Appealing to this basic human desire—to be attractive, to wear clothes and accessories that accentuate one's best qualities, and to create an identifiable personal image—should be the focus of your visual solution.

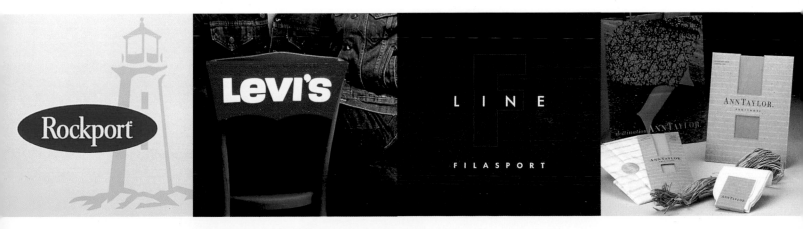

fashion and fitness

a successful fashion logo must establish a personal signature for an entire collection. Fashion logos say: "Wear me and you'll become the person you always dreamed of being." They attempt to personify the target audience's perceived optimal self-image—their personal point of difference—not just the product's formulated personality.

Fashion designers closely monitor economic, cultural, and social shifts, looking for clues to the next potential hero or heroine their audience can emulate. For every new influence, there's a new batch of style purveyors ready to fulfill the latest consumers' dreams.

CLIENT: Ann Taylor
New York, New York
DESIGN FIRM: Desgrippes Gobé & Associates
New York, New York
CREATIVE DIRECTOR: Peter Levine
PRIMARY PACKAGING: Kenneth Hirst
ART DIRECTOR: Frank Ullenberg
DESIGNERS: Christopher Freas, Kim Tyskce

Ann Taylor's image appealed to young, business-oriented women looking for quality and style in the medium price range. By the 1990s, the majority of the Ann Taylor audience had matured, and their tastes had become more sophisticated. The new logos were carefully designed to reflect these new desires of consumers.

Fashion designers create an imaginary person, dress her or him, and enhance her or his best features before they present their creation to an audience—who are encouraged to emulate the finished product. The logos that represent these packaged personalities must reflect an equivalent amount of cultural research and visual attitude to the garments themselves. For the logo designer, a careful study of the constructed personality is the key to success.

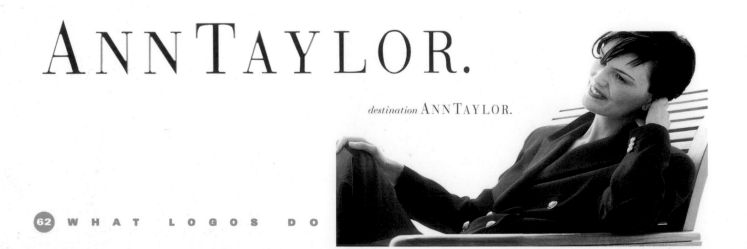

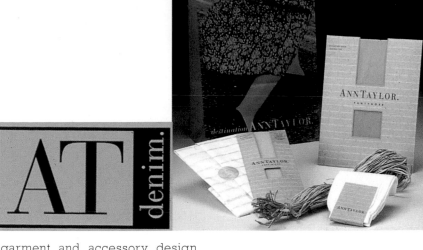

In addition to such conventional applications as stationery, packaging, and labels, fashion logos often are used as prominent visual elements in garment and accessory design. "Signature" clothing has become an essential, highly profitable segment of big-name collections. Chanel, Gucci, Louis Vuitton, Tommy Hilfiger, and other top names have fans who proudly wear their favorite fashion designers' names in public—badges that identify consumers with particular styles and attitudes.

ANNTAYLOR.

These elements do change with time: Changing consumer tastes and expanded product collections can instigate the review of even the most solidly branded cosmetic or fashion identity. Desgrippes Gobé & Associates, a New York–based identity firm with offices throughout the world, was responsible for the revitalization and enhancement of one well-known, sophisticated fashion signature.

Ann Taylor—an exclusive women's apparel chain—had a successful identity program running for nearly two decades. However, it began to look less timely and more dated by 1992. The company was in the process of expanding its collection with the addition of shoes, toiletries and a fragrance, denim jeans, sportswear, and casual wear. And the firm was facing tough new competition. Donna Karan and Dana Buchman had expanded their collections to include clothes that could be worn after hours and on weekends, as well as moderate- and low-priced lines. They also had

The new Ann Taylor logo reflects the personality of a woman who demands style, fine workmanship, and comfort from her clothes. Clean lines, elegant colors, and Ann Taylor's signature quality can be seen in the type treatment via its many applications.

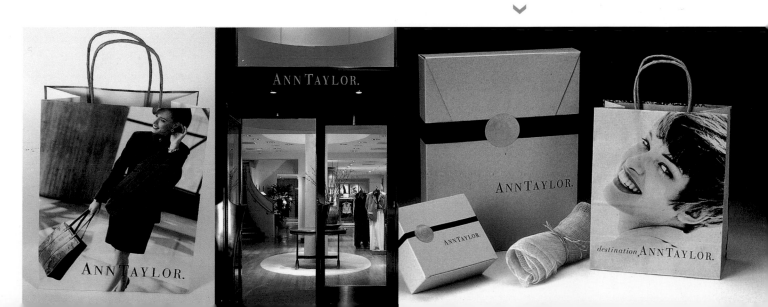

‹

Ann Taylor's ATdenim (jeans) and ATAction (sportswear) lines mirror the primary identity but convey the message that these collections are solid garments designed for sports-minded women.

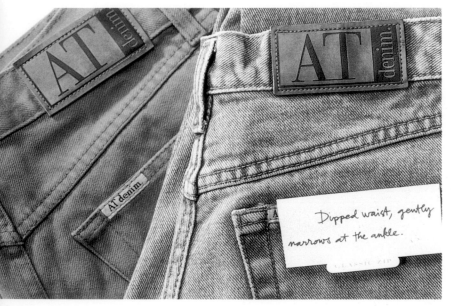

Dipped waist, gently narrows at the ankle.

taken an increasingly sophisticated approach to answering the needs of their consumers. Therefore, by creating a broader brand identity and maturing Ann Taylor's character, the company concluded that it could remain on the cutting edge of this large market segment.

The Desgrippes Gobé design team helped Ann Taylor mature its image by refining the firm's umbrella corporate image—an especially challenging task because the logo also served as the stepping stone for a new series of spin-off identities. Continuity throughout a multiple-identity program is achieved by the careful selection of a strong, concentrated color palette of two to four hues and a primary typeface with a broad range of weights. And that's precisely what the design team did. An elegant, no-frills blue replaced the original vibrant lipstick red to match Ann Taylor's evolving "personality." The team also added a rich raspberry red and muted cadet gray to the master palette.

The original type treatment reflected the ambitious attitude of young, single women who were upwardly mobile. The Desgrippes Gobé team updated the treatment by adding a touch of mature sophistication—choosing Bauer Bodoni as the foundation typeface, which still conveys the strength of the original identity but enhances it. The change from cap/lowercase to cap/small caps type reinforces the concept.

From this core design, the Desgrippes Gobé team developed five spin-off logos. Two of these secondary logos were used on the company's new signature clothing lines. The ATdenim jeans logo on the pocket label and signage shows the central elements of blue color and Bauer Bodoni type. A framed variation that accentuates the AT was created for a leather signature patch above the back pocket. Similarly, the ATAction identity appears on sportswear items such as T-shirts. However, to establish its own branding, separate from Atdenim, the ATAction logo uses Bauer Bodoni italic and raspberry-red color accents.

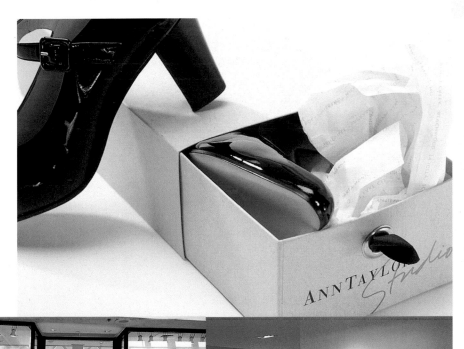

The company's shoe collection, Ann Taylor Studio, maintains the distinctive Ann Taylor name. Since this is a stand-alone store chain, it was important to brand the stores with the parent identity.

❮

Destination—Ann Taylor's signature
fragrance—presents the same clean,
but very intimate, image. The matching
toiletries line also conveys this personal,
nonfrilly note.

destination

ANN TAYLOR.

Rather than relying on a single type family, the team selected two subordinating typefaces
that contrast with the direct look of Bauer Bodoni. Hand-scripted type appears on the firm's
two accessory collections. This signature adds a warm, feminine touch, without diminish-
ing the branded Ann Taylor personality. The logos for the Ann Taylor Studio shoes collec-
tion and the Destination line of Ann Taylor signature toiletries bring new multifaceted
dimensions to the overall package.

The lean-and-mean marketing approach of the 1990s also guided the firm to introduce a
clothing line that returns to wardrobe basics. This collection of lower-priced casual wear
was marketed through its own chain of stores that compete with the outlet shopping-mall
market. The no-nonsense sans serif in the Ann Taylor Loft logo conveys both practicality
and simplicity.

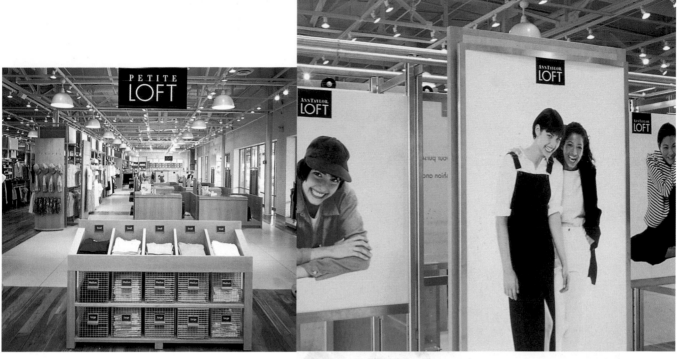

▲ The focus of the Ann Taylor Loft is the
budget- and style-conscious women looking for
casual wear that does not cut corners on quality.

The entire package of visual elements applied throughout this
series achieves its ultimate goal: an image that consumers feel is
part of what they are or aspire to be. The invisible success of the
design's solution, however, lies in its potential. The series' strong
design foundation allows for the future growth of Ann Taylor's
personality as it changes to suit the times.

NINE STITCHES
TO THE INCH

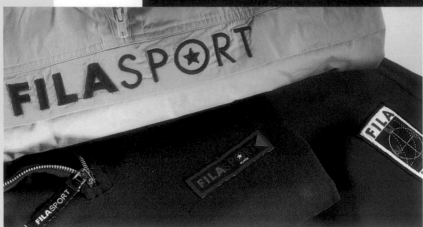

FILASPORT

Because fashion logos are often used in the garment and accessory designs themselves (as printed or embroidered insignia on T-shirts and baseball caps; or woven into the actual fabric) you must ask yourself: Can my solution be easily stitched on a sewing machine, be made into a silkscreen template, impressed into leather, be woven into fabric, or engraved onto metal clasps? Will it still be recognizable in all of these mediums? If your client plans to use any or all of these applications, you should be sure your design budget covers test models that can be carefully reviewed by both you and your client.

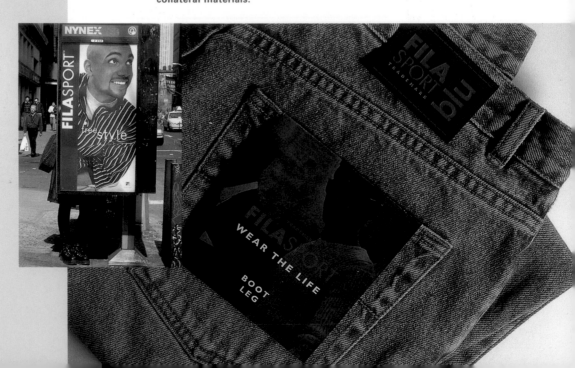

CLIENT: FilaSport
New York, New York
DESIGN FIRM: Desgrippes Gobé & Associates
New York, New York
CREATIVE DIRECTOR: Peter Levine
ART DIRECTOR: Sarah Allen
DESIGNER: Michael Milley

The FilaSport identity is used as an integral part of the actual high-quality sportswear and accessory designs. Using an evocative, bright color palette, the Desgrippes Gobé design team developed series of bold logo treatments so that the fashion manufacturer could brand a signature in a variety of ways throughout the collection as well as on collateral materials.

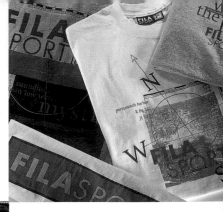

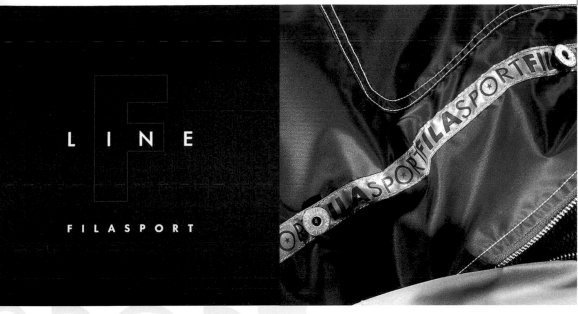

L I N E

FILASPORT

FILA
SPORT

F Line—FilaSport's dressier collection—is
geared to the same audience that has grown
to love the original sportswear collection,
but wants a clean, stylish look that gets down
to business. Applied to collateral materials
and clothing labels, Desgrippes Gobé's clean,
masculine, upscale solution clearly conveys
its well-tailored image to a young,
sophisticated, business-oriented audience.

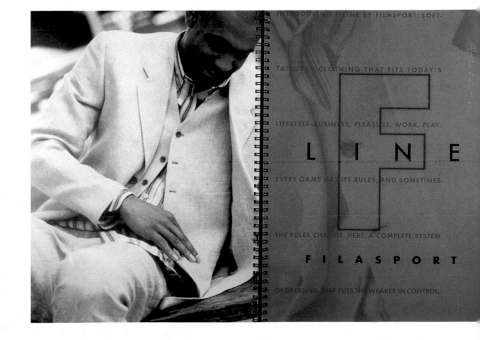

MARK CROSS

NEW YORK

CLIENT: Mark Cross
New York, New York
DESIGN FIRM: Desgrippes Gobé & Associates
New York, New York
DESIGN DIRECTOR: Frank Ullenberg

This New York leather-goods manufacturer
branded their identity more than a century
ago with a lion-head insignia and distinctive
monogram. The demand for an updated image
stemmed partially from the fashion trend
toward imprinting fashion logos on actual
product lines. The Degrippes Gobé design
team developed a proprietary typeface and a
refined insignia that could easily translate as
a stamp on metal buckles and fixtures. The
optional horizontal and vertical logo versions
expanded the identity's utility on other items
such as shopping bags, gift bags, wrapping
ribbon, and stationery.

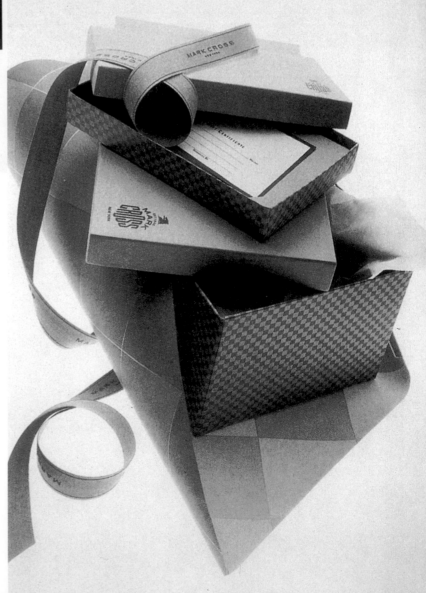

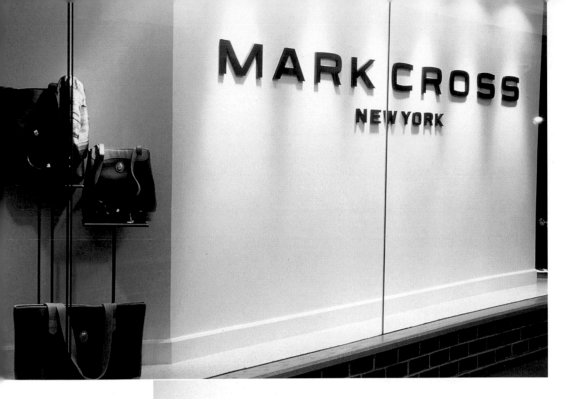

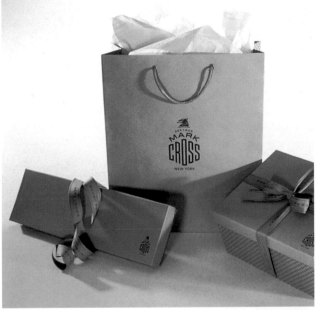

Simplicity and naturalness
are the truest marks
of distinction.
—*W. Somerset Maugham*

TIP

Often it's the most
complex products that
need the simplest
logos. If you can't sum
up an identity in a
single, simple image,
chances are you don't
understand your client's
company well enough.
Give them a good
foundation that can
be expanded—not
reinvented—in case
they decide to diversify
their interests in
the future.

CLIENT: Rockport
Marlborough, New York
DESIGN FIRM: Desgrippes Gobé & Associates
New York, New York
CREATIVE DIRECTOR: Wendy Hald
ART DIRECTOR: Steve Schappacher
SENIOR DESIGNERS: Mark Ollor, Amy
Ingrassia, Werner Franz
PROJECT TEAM: Mary Meier, Victoria Kirk

Knowing when not to embellish is as much an art as creating avant-garde, cutting-edge identities. Rockport has manufactured footwear since 1971, with comfort as their first priority. No splashy abstract emblem could ever speak as strongly of the company's New England roots and down east integrity as a simple text treatment set in a variety of tranquil tones.

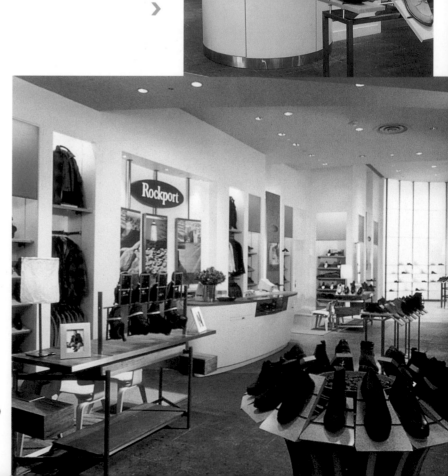

TIP

Get in the habit of writing a standards manual as you develop your program. This is a great way to double-check your design for continuity flaws or gaps in planning. Did you remember to specify CMYK alternates for your PMS colors? Have you established ground rules for sizing or reshaping your logo? Set the ground rules down on paper for yourself and your client.

CLIENT: Levi Strauss & Company
San Francisco, California
DESIGN FIRM: Landor Associates
San Francisco, California (corporate office)

The world's largest apparel manufacturer has come a long way in its 145-year-long history, but they'd also gained a few competitors in the last few decades. To strengthen their overall house brand, Levi Strauss & Company commissioned Landor to develop the "batwing" symbol, which was inspired by the stitching on the rear pocket of their jeans.

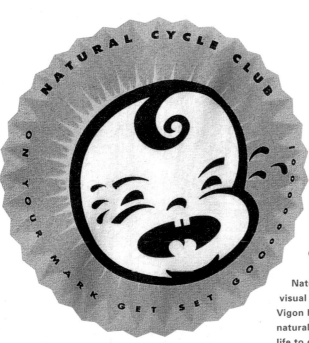

CLIENT: Natural Cycle Club
Studio City, California
DESIGN FIRM: Jay Vigon Studio
Studio City, California
CREATIVE DIRECTOR: Jay Vigon

Natural Cycle Club was born from a visual conceptualization of Darwinism Vigon had one day, focusing on the natural cycle of life from birth through life to death and rebirth. The entire logo series has been translated to wearable art, including T-shirts and baseball caps.

CHAPTER

health care

hospitals, drug manufacturers, and other segments of the health care industry go virtually unnoticed by some portions of the population and are a matter of life and death to others. People seeking health care suddenly find themselves immersed in a sea of corporate identities they may never have noticed previously.

Rather staid in the past, the health care industry is becoming increasingly competitive as consumers are offered more and more choices. From new insurance companies to generic drugs to health maintenance organizations to alternative medicines, these companies are vying for an aging population's business and acceptance. In terms of corporate identity, this rise in competition provides new challenges to designers as well. How do you create an icon that says a hospital is more welcoming, caring, and better or different than other hospitals? How do you portray an insurance company as being firmly established yet capable of providing for individual consumers in times of dire personal need?

CLIENT: CIGNA
Philadelphia, Pennsylvania
DESIGN FIRM: Landor Associates
San Francisco, California
(corporate office)

Before Landor Associates created a new corporate identity for CIGNA (which was formed in 1982 by the merger of Connecticut General Life Insurance Company and Insurance Company of North America), the company's logo was white sans serif type knocked out of a blue background. It closely resembled the logos of dozens of other major corporations, blending in rather than standing out among them. Landor's new identity for CIGNA is far more individualistic, giving CIGNA a more personal and welcoming feel without sacrificing its identity as one of the most successful corporations in the health care industry.

Typically these consumers are in need of comfort, compassion, and assurances of medical expertise. The imagery used to represent health care-related products and services needs to reflect this. Clearly, there is a trend away from the impersonal, more typically masculine professional and business logos of the past. This new

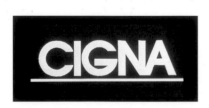

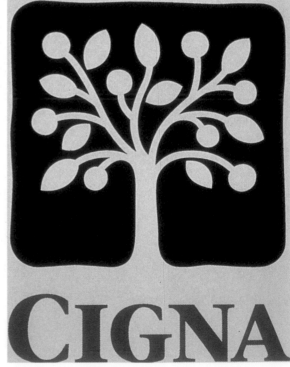

Landor created these Interim Guidelines to guide the art departments of CIGNA's various divisions in the complete and proper use of the new identity. This ensures cohesiveness throughout the corporation, which would be virtually impossible without such a simple yet comprehensive set of standards.

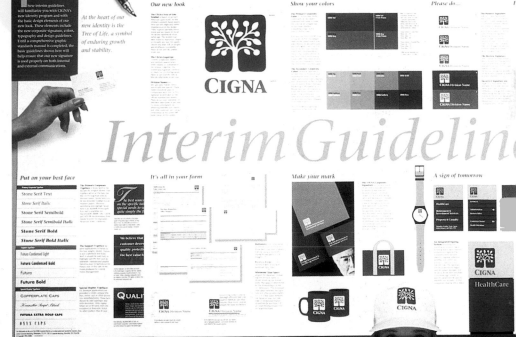

generation of health care imagery is much more welcoming, personal, and reassuring, and it speaks of individual vitality rather than corporate strength and posturing.

The identity program established by Landor Associates for CIGNA Corporation reflects this shift. CIGNA, one of the world's leading providers of insurance and related financial services, used an all-cap bold sans serif logo that was well suited to a major corporation. Analysis, however, confirmed that the logo conveyed an impersonal image.

Homedco

ABBEY
HEALTHCARE GROUP INCORPORATED

▲

CLIENT: Apria
Costa Mesa, California
DESIGN FIRM:
Landor Associates
San Francisco, California
(corporate office)

Homedco Group and Abbey
Healthcare Group merged
to become the world's
largest comprehensive
at-home and alternate-site
medical services provider.
Landor Associates was
asked to create a name
and identity for the new
company. The Apria
(from the Latin word
apricus, meaning "to bask
in the sun") name and
logo comprise a much
more focused, market-
sensitive identity.

The Landor design team selected a "tree of life" motif inspired by an early American quilt pattern, with rounded edges and organic lines. The CIGNA name, in a softer serif typeface, is placed at the base of this icon, where it becomes the roots—in effect, providing the stability and nourishment for the tree of life.

By maintaining the CIGNA acronym and shifting to colors that are compatible with the previous logotype, the transformation was complete enough to give CIGNA an entirely new identity without making such an extreme break that consumers would no longer immediately recognize the image as being associated with the long-standing reputation of the company.

The second challenge was to tie in CIGNA's many and varied divisions under this new umbrella identity. To implement the new system, Landor created a clear and easily accessible set of visual guidelines for its usage.

A standards manual is an essential accompaniment to any thorough identity program, and the *Interim Guidelines* provide an outstanding example. They allow flexibility for the individual divisions and room for

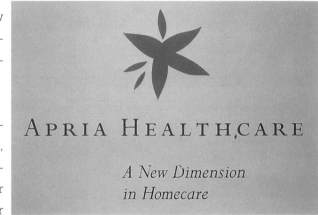

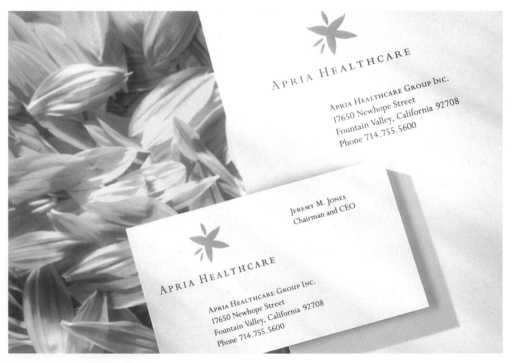

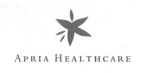

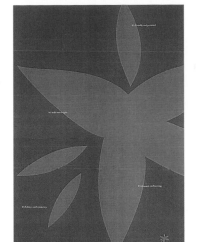

It's in applications, such as the stationery and advertising shown here, that the true nature of the Apria identity becomes apparent. The organic, upswept, almost whimsical shape is warm and inviting, countering perceptions of the health care industry as indifferent and impersonal.

numerous variations on the new identity—all within carefully mapped-out guidelines that serve to maintain the cohesiveness of the overall image program. Outlining and displaying primary and secondary corporate colors, it goes on to give examples of proper and improper usage, dictates a complete set of house fonts (again, with samples provided), shows application samples from stationery to signage, and even includes pictures of the logo on promotional pieces such as watches, tote bags, and baseball caps.

Also included in the *Interim Guidelines* is a detailed explanation of the logo and the concepts that went into its creation. This is very important, no matter how self-explanatory a visual image is. Details of this sort will ensure that the identity is properly used and fully and completely understood by both its present and future users. The overall effect of a set of guidelines is that even without the supervision of the originators, the integrity of the carefully crafted visual identity will be maintained.

(A classic example of a studio that did not put together a graphic standards manual to accompany its logo is Ben & Jerry's Inc.'s in-house art department. Prior to the 1997 redesign, Ben & Jerry's designers had generated fifteen different logo treatments and likely would have generated more had management not insisted on approving every piece of work. While such tight supervision may be feasible for a small company for a short time, it's roughly equivalent to a restaurant chef not writing down his recipes—there's no guarantee of continuity and too much room for interpretation.)

Another of Landor Associates' successful projects further illustrates the logical, visual evolution toward accessible, caring images for health care, though from an entirely different approach.

When Homedco Group and Abbey Healthcare Group, providers of comprehensive at-home and alternate-site medical services, merged to form the world's largest provider, management realized that some customers might be concerned about a loss of personalized services.

Landor was asked to come up with a new visual identity as well as a name for the newly formed health care company. Landor's naming group produced the name *Apria*, derived from the Latin word *apricus*, which means "to bask in the sun." The logo Landor created to accompany the new name is a sunny abstract that could be interpreted as either a flower or a person with outstretched arms. It works because in either interpretation it contains essential elements expressing joy, warmth, and vitality.

Effectively countering consumers' views of the health care industry as indifferent and impersonal, this subtle imagery creates a distinctly welcoming and gentle feeling, giving very personal and humanistic expressions to the company.

In health care, as in any market, a good logo reflects consumers' desires as well as visually representing the company it stands for. This is how a logo becomes an effective marketing tool.

CLIENT: SED Medical Labs
Albuquerque, New Mexico
DESIGN FIRM: MacNab Design
Albuquerque, New Mexico
CREATIVE DIRECTOR:
Maggie MacNab

A chemical beaker and a digitized drop of liquid quickly convey this laboratory's focus: the testing of materials using computer technology. It's a level of confidence and care that the company's medical clientele demand from such sterling services.

You've heard the advice: Boil it down to a single image that captures the essence of the product or company it's meant to represent. But what the heck is an essence? It can be something as concrete as a horse to represent a horse farm or as esoteric as a pair of wings to represent a car or a tree to represent a health care facility. And there are different approaches that can be applied: elements of humor, sex, elegance, safety, dependability, and excitement all can be focused on to portray the essence of a product. The Vices & Virtues logo (see Chapter 6) is sexual; its color, curves, and imagery have all the allure of a pair of parted lips, subtly tempting people to visit the Website. Hornall Anderson's Alki Bakery baker (see Chapter 1) is humorous, with cartoonish curves, promising a fun time to consumers. Landor Associates' FedEx logo (seeChapter 3) is quick, using a bold, business-like abbreviation and a combination of colors that wouldn't be out of place on a Kentucky Derby jockey to assure consumers that their packages will get noticed by their recipients. Once you've refined your thoughts down to a single shape, a typeface, and a color that represent the theme of your message, you'll know you've found its essence.

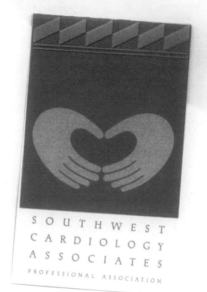

SOUTHWEST
CARDIOLOGY
ASSOCIATES
PROFESSIONAL ASSOCIATION

WILLIAM BENGE, M.D.
PAUL T. COCHRAN, ?
JAMES K. CONRAD
K. JOHN HEILMA
CHARLES H. KA
RICHARD D. LUEKER, M

SOUTHWEST
CARDIOLOGY
ASSOCIATES
PROFESSIONAL ASSOCIATION

T I P

Don't be afraid to discard an idea and start fresh. Be prolific. Come up with dozens of potential treatments; then find the best among them. Save your variations with separate file names, or just keep sketching on paper until you run out of thoughts; then keep those drawings on file.

CLIENT: Southwest Cardiology Associates
Albuquerque, New Mexico
DESIGN FIRM: MacNab Design
Albuquerque, New Mexico
CREATIVE DIRECTOR: Maggie MacNab

A pair of comforting hands embraces a heart in a Santa Fe motif and color palette, spelling out the location, the specialty, and the level of service patients will find at this medical facility.

❯

The ability to simplify means to eliminate the unnecessary so that the necessary may speak.
—*Hans Hofmann*

CLIENT: Animal Medical Clinic
Albuquerque, New Mexico
DESIGN FIRM: MacNab Design
Albuquerque, New Mexico
CREATIVE DIRECTOR: Maggie MacNab

Animals deserve the best health care, just
like their owners, and this facility obviously
wants to help heal wounds in a warm,
nurturing atmosphere.

CLIENT: Body Wisdom Day Spa
Santa Fe, New Mexico
DESIGN FIRM: MacNab Design
Albuquerque, New Mexico
CREATIVE DIRECTOR: Maggie MacNab

Open hands welcome this health facility's
clientele to a place where they can be nurtured
by professionals who are as well versed as wise
owls in reflexology, aromatherapy, and other
healing arts.

T I P

Though you may run
through hundreds of
ideas while creating
an identity, never show
your client more than
three or four possible
solutions. And be
prepared—If a client
views options *A*, *B*, *C*,
and *D*, it is likely to
want option *E*, an
amalgamation of bits
from each. A good
designer anticipates
this and experiments
with the possible
alternatives ahead
of time.

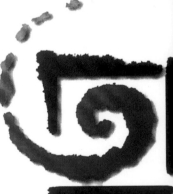

fine-tuning your mark for the media

there's another must-have that everyone demands: entertainment. No one wants to feel the empty, disgruntled emotion Queen Victoria summed up when she first proclaimed, "We are not amused." And in our modern culture, no one wants consumers to declare, "We are not amazed." Driven to deliver cutting-edge information or leisurely diversion to jaded audiences, publishing houses, film and television production companies, Internet service and content providers, and music production companies weave their visual identities around their ability to provide media-hungry consumers with fresh forms of amusement and education. Your bottom-line message in this cutthroat world where everybody's got a gimmick and everything's got to have sizzle is "Let me entertain you."

But how do you develop a media-oriented identity? First of all, the image's personality must be flexible. This particular industry has experienced phenomenal technological advancement. Companies release new and different ways to excite already overstimulated audiences on an almost daily basis. The logo may appear on the spine of a book, a magazine or newspaper cover, a feature film or television broadcast credit, or an audio CD on one day. But who knows? In the near future it might become an animated GIF on a Website or a lifelike, three-dimensional character in a virtual reality environment. Anything is possible, so you might as well plan for it.

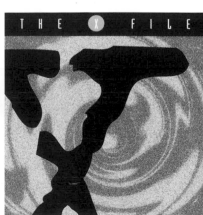

6

entertainment and the internet

esigning an identity that can compete in the huge Internet market but still function in more conventional branding media is one of the toughest challenges facing identity designers today. The Internet is a relatively young medium whose impact over the past three years has been global. No flash-in-the-pan novelty, interactive media such as America Online, @Home, and millions of low-and high-bandwidth Websites are making a library of archival information, current events, and special-market products/services available to a growing list of Web surfers. Your design solution for an Internet identity, a television credit, or a motion picture film's title screen must instantly promise entertainment. It has to convince consumers that they will have fun as either observers or participants in a leisurely activity. It has to guarantee relief from the everyday routine. And as the instant gratification provided by television remotes, the surfing capabilities provided by the Web, and the pacing of most contemporary blockbuster films squeeze attention spans shorter than ever, logos for these products must be more engaging.

The medium's technology is constantly changing, yet consumers themselves are not buying the latest software or hardware concurrent with the rapid evolution. Consequently, designers are faced with finding solutions that will be visually appealing on low-bandwidth, slow-loading systems as well as cable-modem–driven, full video animation-capable browsers. The same (or slightly augmented) solution also must work in collateral, stationery print advertising and promotional situations.

One more factor adds to the complexity: The Internet audience is not only visually oriented, they are also demanding. Weaned on television commercials and blockbuster motion pictures, these consumers demand high-quality entertainment—even from the opening splash screen of a Website that displays only a logo. To be viable, the design solution has to be everything to every viewer.

iVillage, Inc., is a Manhattan-based content developer that creates popular programming geared toward consumers' special interests. Parent Soup was the first

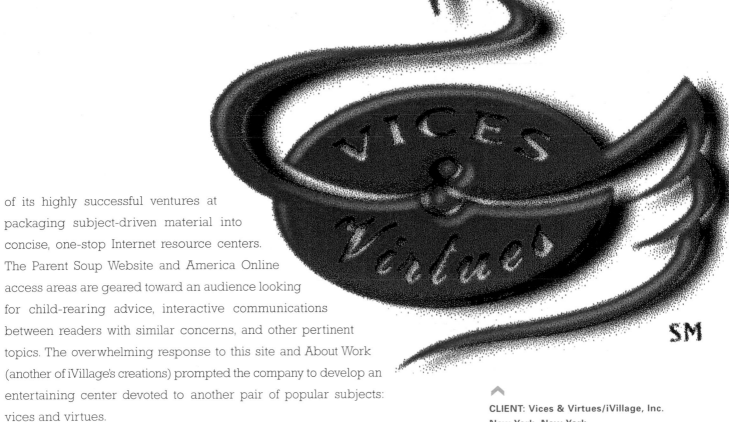

SM

of its highly successful ventures at packaging subject-driven material into concise, one-stop Internet resource centers. The Parent Soup Website and America Online access areas are geared toward an audience looking for child-rearing advice, interactive communications between readers with similar concerns, and other pertinent topics. The overwhelming response to this site and About Work (another of iVillage's creations) prompted the company to develop an entertaining center devoted to another pair of popular subjects: vices and virtues.

The Vices & Virtues brand not only appears at the America Online area and the World Wide Website, it is also applied to cobranded sites that are part of the extended content family. The final design solution also had to take into consideration the broad variety of design elements found on those pages as well. iVillage's design team met this multifaceted challenge with a clean, simple, and visually strong icon that is still strong and legible despite its under-10K file size.

Created by Duffy Design's Neil Powell and Lourdes Banez, this clean, easy-loading design drives home the site's main focus quickly: The devilish tail and angelic wing

CLIENT: Vices & Virtues/iVillage, Inc.
New York, New York
DESIGN FIRM: Duffy Design
New York, New York
DESIGN DIRECTOR: Neil Powell
DESIGNER: Lourdes Banez

Organic, emotional, and youthful, the Vices & Virtues identity appeals to a young-adult audience that's tired of more structured identities. The Duffy Design team refined the sentiments of this market segment down to a succinct portrayal of human weakness when confronted by temptation and the desire for redemption.

emanating from the central oval inform viewers that they are entering a site that promises an entertaining view of human weaknesses like food, drink, smoking, and sex as well as moral support and advice for those who want to curb their pleasure centers by going on a diet or on the wagon.

The design team wanted the logo to be bold and irreverent, so they chose a red color palette and a combination of hand-drawn and hand-modified typefaces to convey a sense of contrasting emotions. The online version of the Vices & Virtues identity is lightly shaded to give it a richer, three-dimensional appearance on screen, where it is accompanied by a variety of stable, moving, and changing full-color images. In this usage, the logo serves as a fulcrum—a common denominator in a highly active environment. Since the Internet allows for more variation in application than more conventional media, there are plans to eventually give the logo itself life: transforming it into an animated GIF sequence.

A two-dimensional version of the logo is used on ancillary applications such as stationery, collateral presentation folders, and even temporary tattoos. There are also plans to use this version as a "shorthand reminder" on all the site pages "kinda like the little logo blazed into the corner of your TV screen on certain networks."

The Vices & Virtues logo is effective because, although it is much subtler than a pair of slightly parted lips, its color and imagery are no less sexual. This is just the allure that is needed to attract young adults to a Website that provides entertaining information about drinking, smoking, eating, sex, dieting, and other pleasures and pains. The image is not at all businesslike. It clearly doesn't herald a public information forum. It titillates—offering a good time whether you're feeling naughty or nice.

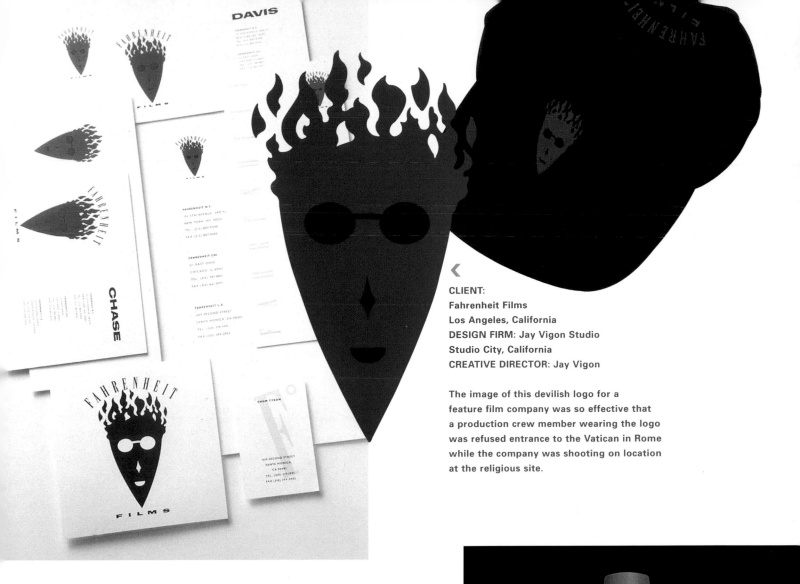

CLIENT:
Fahrenheit Films
Los Angeles, California
DESIGN FIRM: Jay Vigon Studio
Studio City, California
CREATIVE DIRECTOR: Jay Vigon

The image of this devilish logo for a
feature film company was so effective that
a production crew member wearing the logo
was refused entrance to the Vatican in Rome
while the company was shooting on location
at the religious site.

CLIENT: Technicolor
Hollywood, California
DESIGN FIRM: Landor Associates
San Francisco, California (corporate office)

The Technicolor process has been around
since 1915, and its innovations have been
seen on the big screen as well as on
video, television, and CD-ROM. This broad
expansion inspired the company to look
for a revitalization of its identity that
would include some of its more recent
advancements. Using the aurora borealis
(northern lights) as an inspirational source,
Landor created a contemporary dynamic
image that reflects both the company's
heritage and its diversified presence
in the motion-picture industry.

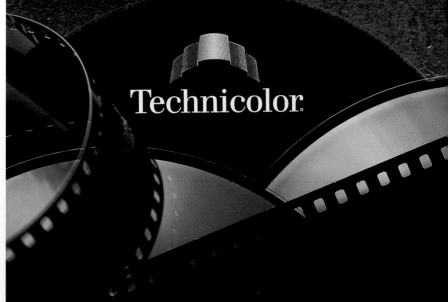

THE MEDIUM IS THE MESSAGE

> The wisdom of life consists in the elimination of nonessentials.
> —*Lin Yutang*

Designing a logo for an Internet-based presence is in many ways no different from developing an image for print applications. The Duffy Design team had some sage words of advice about Website icons: "Like any other logo, make 'em simple. They should convey the whole idea with as few elements as possible so users can grab it in one eye swipe. Make 'em memorable, because that's what logos are for. If they aren't distinctive, you might as well just put the name of the item in plain black ASCII text and save the design fees. Finally, don't make it too fashionable, because someday it's going to go out of fashion, and then you'll look like a Members Only jacket." Need we say more? The medium may be the message, but to convey your message, you've got to think "simple" and "original."

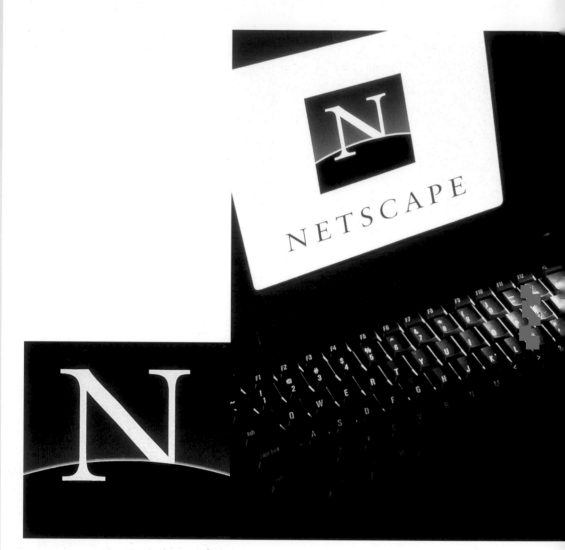

CLIENT: Netscape Communications
Mountainview, California
DESIGN FIRM: Landor Associates
San Francisco, California
(corporate office)

Founded in 1994, this company was largely responsible for the worldwide Internet explosion thanks to its development of an easy-to-use, point-and-click navigational program. Landor had to consider the logo's varied applications, from a 32 x 32 pixel on-screen GIF to stationery, collateral, and print advertising. The bold *N* rising above the world clearly conveys Netscape's mission: global access to information.

CLIENT: Channel 5
London, United Kingdom
DESIGN FIRM: Wolff Olins
London, United Kingdom
EXECUTIVE CREATIVE DIRECTOR:
Douglas Hamilton
CREATIVE DIRECTOR:
Robbie Laughton
DESIGNERS: Phil Percival,
Daren Cook
PRODUCTION: Adam King

With a target audience of
under-forty-year-old British
television viewers who are
bored by the nominal offerings
found on the four older broadcast
channels, Channel 5 was
determined to launch itself
nationally with a bang.
The company recruited the
Wolff Olins design team
to create a young,
upbeat image that had
plenty of room for
variation. The final
color palette of five
vibrant primary colors
is anchored to the
identity by the unifying
strength of the main icon—
the number *5* surrounded by
a circle—and Frutiger as the
logotype. Another facet of
the program is the use of tuning
bars that were created in the
same lively color scheme.
The overall effect guarantees
viewers that this national
network channel is anything
but static or conservative in
its programming.

❯

THE X FILES

TIP

If you're going to be thinking anyway, think big. This doesn't mean that every design has to be grandiose. It does mean that every design should be your best work to date. Think about your logo the same way your client perceives his or her business: It's going to grow and be seen by an ever-expanding audience. Your final design should be ready for bigger and better applications as technology dictates; it should be ready to represent subsidiary businesses as an umbrella presence.

CLIENT: *The X Files*
Beverly Hills, California
DESIGN FIRM: Twentieth Century
Fox Film Corporation
Beverly Hills, California

Capturing the imaginations of the television public with its stark imagery, *The X Files* logo flawlessly communicates the show's inherent duality. The orderly surface of government is represented in the top bar, with the dark, mysterious, and ethereal depths lurking below the surface. The subtle spiral shape of this logo is also particularly fascinating. It draws the viewer's attention inward, trapping it and drawing it around in a circle, effectively holding the viewer's eye for a longer period of time.

CLIENT: 21stC/Columbia University
New York, New York
DESIGN FIRM: Interactive Bureau
New York, New York
CREATIVE DIRECTOR: Roger Black
DESIGNER: Paul Barnes

21stC is an online academic research journal published by Columbia University. Its futuristic focus and use of new technology are reflected in the logo Interactive Bureau created for it. The logo takes on the shape of a spotlight in a traditionally modern form (think of the spotlight Commissioner Gordon used to signal Batman), which is fitting for a journal high-lighting forward-thinking research about society and the future in general. The logo also works well throughout the Website as a background for section headings (www.21stC.org).

A trendy design is the best solution if that's what consumers expect from your client's product or service. A bold sans serif type-face in midnight blue on gray may be simple, legible, and timeless, but it would look darned silly on a kid-friendly fast-food restaurant.

CLIENT: @Home Network
Mountainview, California
DESIGN FIRM: Interactive Bureau
New York, New York
CREATIVE DIRECTOR: Roger Black
DESIGNERS: John Miller, John Schmitz

If there is a single symbol that best represents interactive communication and the World Wide Web, it's the "@" symbol. As a stand-alone or with the rest of the @Home Network name, it's a solid visual cue to the company's technological orientation. It is also a prime example of a designer finding the visual heart of a company and distilling it to its simplest form.

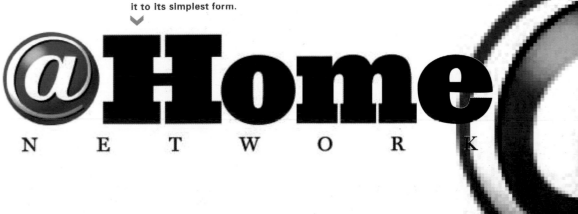

FutureTense

CLIENT: FutureTense
Acton, Massachusetts
DESIGN FIRM: Interactive Bureau
New York, New York
CREATIVE DIRECTOR: Roger Black
DESIGNER: Theo Fels

The logo itself captures the motion of a computer disk; the selection of typeface here adds a vaguely 1950s modern feel. To give the impression of modernity, sometimes the trick is not to use whatever's the latest trend but to look to designs that were created specifically to look modern and to use these as a starting point. Interactive Bureau's choice of cap/lowercase rather than all cap or cap/small cap lends the logo a warmer, less intimidating feel. This is important for a company selling complex software (www.futuretense.com).

Scholastic Network

CLIENT: Scholastic Network
New York, New York
DESIGN FIRM: Interactive Bureau
New York, New York
CREATIVE DIRECTOR: Roger Black
DESIGNER: John Schmitz

Bright, bold, and lively, the Scholastic Network logo, created by Interactive Bureau for Scholastic, Inc., an educational publishing company, is a very quick read—matching the attention spans and visual stimulation requirements of school-aged children, their parents, and their teachers. The globe acts as a stand-alone, allowing more flexibility (development.iab.com/scholasnet/).

CLIENT: YPN (Your Personal Network)
New York, New York
DESIGN FIRM: Interactive Bureau
New York, New York
CREATIVE DIRECTOR: Roger Black
DESIGNERS: Theo Fels, John Schmitz, Steve Gullo

As the title of a popular Website, the YPN logo has the attention-grabbing appeal of a tabloid or magazine logo. Like a stylish flashcard—this instant accessibility is a strong branding for a site that's geared toward entertaining young adults in a fast-paced, interactive setting. Though the graphic is very simple—an oval containing a minimum of very plain text—the effect of the color and arrangement is powerful and distinctive. Note the size of the text in relation to the oval. By extending it to the edges, no space is wasted, and the readability is increased, even at small sizes (www.ypn.com).

CLIENT: NetResponse
Arlington, Virginia
DESIGN FIRM: Interactive Bureau
New York, New York
CREATIVE DIRECTOR: Roger Black
DESIGNER: John Schmitz

NetResponse is an Internet/intranet consulting firm. To represent a highly successful and rapidly growing firm in a new field that's ever-changing, anything but an abstract image would soon become obsolete. And with the potential for so much change, an unchanging logo, especially one that can be expanded on by changing the accompanying type, quickly brings a feeling of stability—which can be nearly as strong a reassurance to potential clients as a strong portfolio (www.netresponse.com).

special events

Sports-related imagery is affected by some of the most rapidly changing trends in the business world. For most sporting goods, the graphic imagery changes, whether it's subtle or drastic, with every new season. Much like the haute couture runways of Paris, ski, tennis, bicycling, and other sporting-goods stores are filled with new lines of colors, styles, and graphics aimed at enticing consumers to be up-to-date, convincing them graphically that the new season will be better with the newest equipment and the newest clothing with the latest brandings and that equipment and clothing from previous years will look old in comparison. Historically, companies haven't had too much difficulty selling this concept. When it comes to leisure activities, sports-minded people fall into a market segment that's constantly in search of new forms of healthy stimulation—that's the nature of both spectator and participatory sports.

For designers, however, this means constant vigilance, staying on top of the trends or ahead of them if possible, and with great effort, creating them if necessary. A design that doesn't fit the current style may start a new trend, or it may fail to entice consumers. All of this becomes even more challenging when the sports identity is for a single event, especially when that event is large enough that the identity will be used for years in advance and has the potential to become a collector's item as a graphic on pins or other commemorative items. Such a widely popular sporting event is the Olympics, and this is exactly the challenge Landor Associates faced when it was selected to design the identity for the XVIII Winter Olympic Games in Nagano, Japan.

The Olympic symbol—five interlaced rings—has been in use for many decades. More recently, however, a new category of visual symbol has joined it. Accompanying the Olympic rings, or even used on its own, is a separate and distinctive identity created for each Olympiad, contracted by the organizers in the host community. This image is then used as the primary visual representation of those particular games for purposes of worldwide marketing, branding, and commemoration. Since it is so widely used in promoting the games, the logo itself undoubtedly can contribute—though intangibly—to the success of the event. Thus it is essential that it be on target.

Adding to the challenge Landor Associates faced, the Nagano Games' Organizing Committee had a number of rather esoteric but commendable ideals they wanted their symbol to represent to set a positive tone for the games: a link to the twenty-first century, respect for the beauty and bounty of nature, and the furtherance of world peace and goodwill.

More than one hundred Landor employees worldwide worked to produce a final logo. Their approach was to define the overall look of the games. Using an international electronic network and a collaborative effort, the designers generated more than one thousand designs for consideration. It took five months, but it was out of these designs that the final logo was selected. A motion-filled abstract of six athletes radiating out from a center point, the emblem takes on the hexagonal shape of a snowflake when viewed in outline form. In full color, it has the character of a delicate alpine flower, reflecting the environmental awareness of the community hosting the games. The overall effect is a distinctive, highly recognizable symbol that's kinetic and abstract enough to represent all the activities taking place and bright enough to be recognizable when it passes crowds of spectators on the back of a skier coming down the hill at 70 miles (112 kilometers) per hour.

CLIENT: 1998 Winter Olympic Games
Nagano, Japan
DESIGN FIRM: Landor Associates
San Francisco, California (corporate office)

The identity for the 1998 Winter Olympic Games in Nagano, Japan, comprises six athletes emanating from a center area in abstract forms. It is designed to represent the environmental sensitivity of the alpine area where the games will take place and the organizers concern for the environment. At a glance, the shape becomes a snowflake and then an alpine flower. Appearing on everything from advertising, to promotional and retail items, to the site itself, it is essential that the symbol represent both the event and the location where it is taking place.

The final logo appears in advertising, on signage, and on collectible items ranging from telephone calling cards and lapel pins to T-shirts, jackets, hats and bags, and much more. For the majority of the attendees—especially the hundreds of athletes and the thousands of people directly connected to them—items emblazoned with this symbol will no doubt become lifelong mementos representing some of the best and most memorable times in their lives.

One of the restrictions in designing a logo for an event such as the Nagano Winter Olympic Games is that the image must be readable from a great distance. Shown here under the lip of a ski jump, the image makes appearances at high points around the Olympic village, serving to cohesively brand the various individual contests as well as the spectator areas and participating local businesses under the umbrella of the overall event.

If Landor had created a symbol relying on traditional elements of Olympic imagery—the interlaced rings, the torch, the flame—as has been done for other Olympic games elsewhere, the result would have been an image that represents the Olympics more than it represents the Nagano winter games in particular. By differentiating the Nagano logo sufficiently and working in elements reflecting the character of the individual event, Landor created an image for its Nagano-based client that will remind the world specifically of the Nagano event—before, during, and for years after.

In contrast, Landor Associates identity design for the 1996 Summer Olympic Games held in Atlanta, Georgia, took on an entirely different character, drawing heavily on traditional Olympic symbology. This is a prime example of how different circumstances dictate the ideal representative imagery. The Atlanta games marked the centennial of the modern Olympic games, so it was crucial to mark the anniversary through these traditional visual elements. Since the games were held in the United States, the torch (which, thanks to the Statue of Liberty) and the stars (a prevalent feature on the American flag) are very recognizable internationally as American icons.

CLIENT: High-Tech
Seoul, South Korea
DESIGN FIRM: Desgrippes Gobé & Associates
Tokyo, Japan

Communication materials created for the
French technology exhibition that was held in
1995 bore a visual identity that purposefully
humanized the otherwise cold approach to
technology by portraying a person who's
obviously thinking about the future.

Size matters! Get to
know your design by
viewing it as large and
as small as possible
and at increments in
between. Most important,
you know your finished
treatment most commonly
will be seen in certain
sizes. Review each
version carefully and
often during the develop-
ment process.

Logo designers need to stay on top of the trends—or ahead of them, if possible. A design that doesn't fit the current style may start a new trend, or it may fail to entice consumers. The challenge to stay at the cutting edge becomes even more daunting when you're designing an identity for a single event— a convention, concert, or Even the most temporary logo deserves concentrated attention; it is, after all, heralding an upcoming occasion. That same logo also might outlive the event itself. Take a look at the highly collectible memorabilia that people purchased at the 1939 World's Fair or at Super Bowl XX. Your single-event identity might go down in history! So take the time to make your solution as memorable as the event it represents.

∧

CLIENT: Microsoft Corporation
$E = ms^2$ Conference
Redmond, Washington
DESIGN FIRM: Hornall Anderson
Design Works, Inc.
Seattle, Washington
ART DIRECTOR: Jack Anderson
DESIGNERS: Jack Anderson,
John Anicker, Mary Chin Hutchison

Microsoft Corporation needed a logo to represent its sales and marketing meeting/world conference. HADW designed the $E = ms^2$ logo to be a play on Einstein's formula $E = mc^2$. In this case, however, the formula references *Energy = Microsoft2*. Similar to the basis of Einstein's theory of relativity, this logo implies a break through the perceived barriers and expanded possibilities for Microsoft Corporation.

There is no greatness where there is not simplicity.
—*Leo Tolstoy*

CLIENT: 1996 Summer Olympic Games
Atlanta, Georgia
DESIGN FIRM: Landor Associates and
Copeland/Landor/Murrell
San Francisco, California (corporate office),
and Atlanta, Georgia

To mark the one-hundredth anniversary
of the modern Olympic games, held in
Atlanta, Georgia, Landor Associates—
in collaboration with Atlanta-based
designers Copeland/Landor/Murrell—
created an Olympic centennial torch. The
torch is a Greek capital (the top of a
column) containing the Olympic rings and
supported by the number 100. The flame
rises into a star, representing the athletes'
goals and achievements. Selected from five
hundred sketches submitted by Landor, the
Atlanta Centennial Torch was unveiled at
the closing ceremonies of the 1992 Olympic
games in Barcelona and was used during
the entire four-year marketing period.

TIP

Winning products are represented by winning symbols—although often the image is created before the product is successful. Look at commonly used images of success, victory, and achievement. Look at these in both general terms and in terms specific to your client's business. And remember, visual imagery is twofold—shape and color. It's up to you as the designer to select winning shapes and colors—and then to pair them in winning combinations.

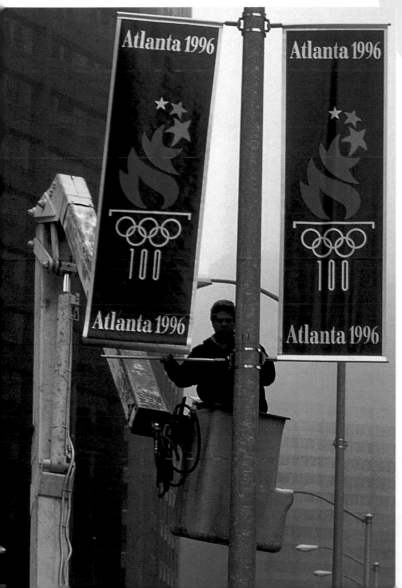

printed and digital publishing

CLIENT: *Le Monde*
Paris, France
TYPE DESIGNER:
Jean-François Porchez
Malakoff, France

Relying solely on the character and shape of this proprietary typeface to communicate the values of accuracy, speed, and efficiency that readers expect from France's national newspaper, Jean-François Porchez developed a modern, yet very classic, typeface that is ultimately legible and "more fitting with the French language and the *Le Monde* newspaper style."

ⓔ very day, hundreds of magazine titles and software packages vie for your attention as you pass newsstands and computer stores. The competition seems to double in size annually. Identity programs for print or digital publishing projects are more visually prominent than the actual physical entities they represent. Book, magazine, and software logos are the visual emissaries for thoughts and ideas, not just products. Unlike an automobile emblem or a fashion designer's label, the typographic treatment on a magazine cover or software splash screen must tell consumers what type of information they are likely to find inside. It must reflect how difficult or easy it will be to read or access the material. Sometimes other graphic elements may accompany the main title, such as *Playboy* magazine's trademark rabbit or Netscape's signature rising *N*, but they are not the identity's driving force. That's the sole domain of the selected typeface.

Newspapers are even more restrictive with their identity programs. Appearing daily or weekly, these purveyors of current news must visually evoke speed, accessibility, accuracy, and respectability within the time it takes the average consumer to decide to pick up a copy at the local newsstand on the way to work. How do you communicate all of these values in a typeface treatment? By concentrating on its legibility at a distance. Despite the prolific number of available typefaces—thousands are available to date—sometimes the solution to this type of logo project means designing a whole new type family to serve your client's purpose.

LUNDI 9 JANVIER 1995

Les ca
typog

graphie
Le Monde »

Quelque

Le Monde

LUNDI 9 JANVIER 1995

Les carac
typograp

Quelques rappel

Caractère typographique Le Monde

La typographie
du journal « Le Monde »

Le nouveau caractère de texte du quotidien « Le Monde »

A l'opposé des caractères de texte pour le livre, qui sont d'un style délicat, les caractères pour la presse quotidienne possèdent des formes issues de leurs fonctions, en terme de lisibilité et de techniques d'impression.

Le choix d'un caractère de texte pour un quotidien doit tenir compte des conditions de lecture. En effet, le journal est souvent lu durant les transports, en mouvement, d'une façon saccadée, hachée au cours de la journée et sous des éclairages très médio-

cres. La qualité du papier, la vitesse d'impression, le type d'impression suscitent un style approprié.

Les caractères destinés à la presse sont plutôt gras, d'un faible contraste pleins/déliés. Le nouveau caractère du *Monde* tente de réunir à la fois l'emphase individuelle de chaque lettre, l'image globale du mot, tout en tenant compte de l'aspect technologique.

L'esthétique ne vient qu'en troisième position. L'apparence d'un quotidien tient essentiellement à

l'aspect qu'offre la ligne de texte. Dans les petits corps, le mot devient une image en soi. Les qualités de style d'un alphabet sont gouvernées par la rapidité ou la lenteur avec laquelle le lecteur lit le texte.

Les bonnes ou mauvaises nouvelles ne sont plus simplement transmises par un caractère neutre, mais par un caractère plus affirmé, plus contrasté.

Le caractère offre au journal *Le Monde* une image de marque que le lecteur peut identifier. ♦

Initialement, les journaux n'utilisaient pas de caractères de texte spécifiques. Durant tout le dix-neuvième siècle, les caractères de type *Didot* étaient les plus couramment utilisés. Créés par François Ambroise Didot [1730-1804] ils se caractérisent par un axe de construction vertical et la suppression totale de tout ce qui, jusque là, tenait encore au tracé calligraphique.

C. H. Griffith, de l'America notype Company, s'intéressa problèmes que posaient les

Read by an audience that spans the entire French-speaking world, France's national newspaper—*Le Monde*—has been in circulation for half a century. Since it first went to press in 1945, the publication and its signature logo have been set in the 1932 version of Stanley Morison's Times typeface. There are many local, regional, and national newspapers that use various cuts of this same font around the globe. Studies conducted during the 1940s, 1950s, and 1960s indicated that it was deemed to be a highly legible typeface by a large audience. However, consumer tastes and needs change: In recent years, it seems, the typeface and logo no longer evoke the high level of legibility that readers need, and in addition, they never gave a strong impression that the publication was French.

The company commissioned typographer Jean-François Porchez to develop a more contemporary, legible typeface that would be "more fitting with the French language and the *Le Monde* style." Drawing his inspiration from early typefaces, especially Humanist handwriting forms and the work of typographic masters such as William Morris, Jan Tschichold, and even Stanley Morison, Porchez sketched the first version of his design completely by hand and then scanned the images into his computer, where he refined each character and digitized the entire character set in a software program called Fontographer for use by the publisher.

Jean-François Porchez
Typographe & créateur de caractères
38bis, avenue Augustin-Dumont
F-92240 Malakoff
Téléphone, Fax 33 {0}1 46 54 26 92
E-mail jfporchez@hol.fr

Programme
famille Le Monde

26 03 1997

LeMonde Journal LeMonde Sans LeMonde Livre LeMonde Courrier

LeMonde
ExtraLight, Osf

LeMonde
ExtraLight Italic, Osf

LeMonde
Light, Osf

LeMonde
Normal, Small caps, Old style figures

LeMonde
Normal Italic, Sc, Osf

LeMonde
SemiBold, Sc, Osf

LeMonde
SemiBold Italic, Sc, Osf

LeMonde
Bold, Osf

LeMonde
Bold Italic, Osf

LeMonde
Light Italic, Osf

LeMonde
Normal, Small caps, Old style figures

LeMonde
Normal Italic, Sc, Osf

LeMonde
SemiBold, Sc, Osf

LeMonde
SemiBold Italic, Sc, Osf

LeMonde
Bold, Osf

LeMonde
Bold Italic, Osf

LeMonde
ExtraBold, Osf

LeMonde
Normal, Small caps, Old style figures

LeMonde
Normal Italic, Sc, Osf

LeMonde
SemiBold, Sc, Osf

LeMonde
SemiBold Italic, Sc, Osf

LeMonde
Bold, Osf

LeMonde
Bold Italic, Osf

LeMonde
Normal, Small caps, Old style figures

LeMonde
Normal Italic, Sc, Osf

LeMonde
SemiBold, Sc, Osf

LeMonde
SemiBold Italic, Sc, Osf

LeMonde
Bold, Osf

LeMonde
Bold Italic, Osf

LeMonde Journal

The main font and weights—Le Monde Journal normal and bold in both roman and italic—reflect the classic, respectable image of the company itself not only in the actual title bar but also throughout the publication's text and head treatments. The characters contain the open feel that appeals to both a large aging population segment and a new readership—a younger generation that's been reared on rounder sans serif typefaces since their elementary school days during the 1970s.

Porchez also designed Le Monde Sans in light, normal, semibold, and extrabold weights of roman and italic to fulfill the need for sans serif typesetting applications. (He was scheduled to complete the final extensions of this family—Le Monde Courrier and Le Monde Livre—last year.)

Looking at the clean, legible character shapes, the timelessness of Porchez's solution is readily apparent. However, the reason this design is timely and immediately successful is that in this global era, when it is more important for *Le Monde*, as a international newspaper, to display its French roots than for *Le Monde*, as a French-language newspaper, to look international, Porchez has masterfully created a balance and communicated it through the letters.

Get black on white.
—*Guy de Maupassant*

CLIENT: Intermation Corporation
Redmond, Washington
DESIGN FIRM: Hornall Anderson
Design Works, Inc.
Seattle, Washington
ART DIRECTOR: Jack Anderson
DESIGNERS: Jack Anderson,
Leo Raymundo, Julia LaPine

When Intermation spun off from its
parent company, it wanted to stand
out in the increasingly crowded
field of data retrieval and storage.
HADW's goal was to convey a
combination of current
technology and warmth—
high tech with a human
face. A bright color palette
and patterned look were
added in the design of the
company's marketing material.

Despite the prolific number of available typefaces—thousands are available to date—sometimes the solution to this type of logo project means designing a whole new type family to serve your client's purpose. Creating a reproducible typeface that can be distributed to your client's various departments or outlets is not as difficult at it may seem. There are a few font-creation programs available in both Mac and Windows platforms that can output TrueType or PostScript versions of your proprietary design. The most popular and easy to learn as of this writing is Fontographer. You can hand draw and scan your initial character shapes for refinement within the program. But you don't have to be a master draftsman to create your initial characters. You also can import an existing font and modify individual characters. Once you've mastered a few program basics, you can develop a truly unique identity for your client all the way down to the proprietary typeface made especially for them.

C O R B

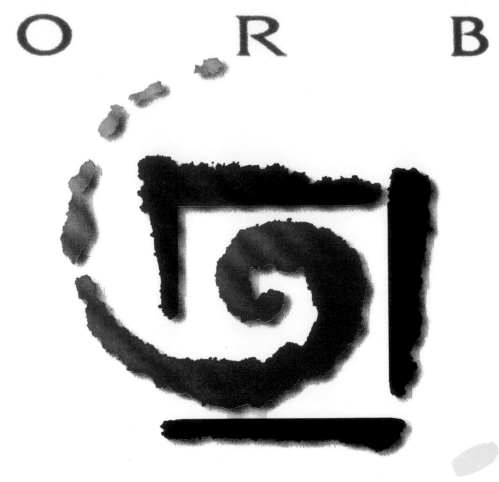

CLIENT: Corbis Corporation
Bellevue, Washington
DESIGN FIRM: Hornall Anderson
Design Works, Inc.
Seattle, Washington
ART DIRECTOR: Jack Anderson
DESIGNERS: Jack Anderson, Julie Lock,
Jana Nishi, Julie Keenan, Mary Chin
Hutchison, Julia LaPine

HADW collaborated with Continuum —a private Bill Gates company—the world's largest digital imagery archive. The company changed its name to Corbis, which was evolved from a Latin root translation meaning "woven basket or container." To illustrate Corbis' services, HADW designed an icon depicting a storage container for information. The swirling emblem represents the information's steady circulation and easy accessibility. Also incorporated are both organic and crisp lines symbolizing how all creations and information have been in some way technically manipulated by humans.

C O R B I S

[EXHIBIT HALL]

[ARCHIVE]

[CORBIS PUBLISHING]
Multimedia Products

[CORBIS MEDIA]
Image Licensing

h t t p : / / w w w . c o r b i s . c o m

Applied to corporate identity, tradeshow posters,
packaging, and a Website, the new identity also was
used on a series of collateral materials,
including a direct-mail piece that introduced Corbis
and previewed its contents and services.

TIP

Experiment. Try every
idea in model or mock-
up form. Sometimes the
best solutions come from
the most unlikely begin-
nings. You can't judge a
logo until you've seen it
in place.

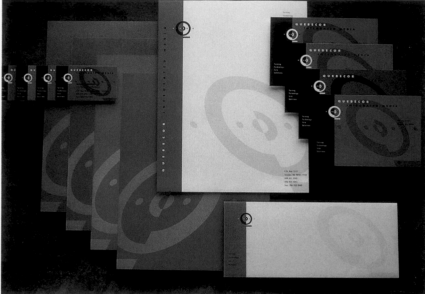

CLIENT: Quebecor Integrated Media
Tacoma, Washington
DESIGN FIRM: Hornall Anderson
Design Works, Inc.
Seattle, Washington
ART DIRECTOR: Jack Anderson
DESIGNERS: Jack Anderson,
Heidi Favour, Mary Hermes,
Mary Chin Hutchison, Julia LaPine

Recently purchased by the Canadian
company, Quebecor—North America's
second largest printing firm—this CD
manufacturer has gone through three
name changes in the past few years.
(It was first called Print Northwest, then
Six Sigma, and now Quebecor Integrated
Media.) HADW used the firm's color
palette—special match blue, green,
terra-cotta, and purple—to retain brand
identity. But the new design had to
retain the corporate Q logo. HADW
restyled the image as a very abstract
circle with a technical look.

CLIENT: PGP (Pretty Good Privacy)
San Mateo, California
DESIGN FIRM: Hornall Anderson
Design Works, Inc.
Seattle, Washington
ART DIRECTOR: Jack Anderson
DESIGNERS: Jack Anderson,
Debra Hampton, Heidi Favour,
Jana Wilson, Katha Dalton,
Michael Brugman

This encryption software
company devised a program that
scrambles e-mail and other digital
correspondence so that it can't
be intercepted over the Internet.
The company's logo is a visual
representation of the software's
capabilities, incorporating a
shade pulled down in front of
a person's face.

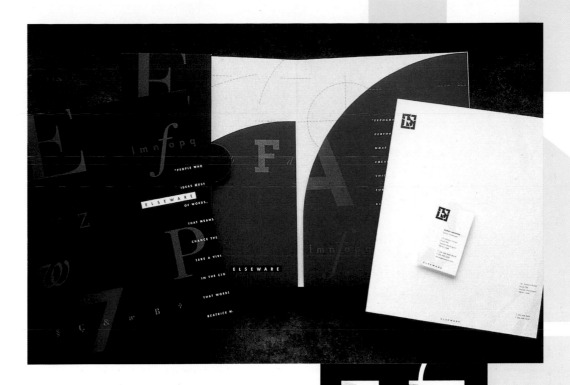

> CLIENT: Elseware Corporation
> Seattle, Washington
> DESIGN FIRM: Hornall Anderson
> Design Works, Inc.
> Seattle, Washington
> ART DIRECTOR: Jack Anderson
> DESIGNERS: Jack Anderson,
> Scott Eggers, Leo Raymundo

This software developer specializes in font manipulation, so its logo had to reflect the evolution of type itself. HADW started with a Bodoni *E*, converting it to paths in FreeHand and customizing the letterform. The DaVinci construction lines are a symbol of typographic heritage: the matrix constructions used in the early design of type. But with the different serif and sans serif elements, this logo maintains a very contemporary look.

TIP

No designer has ever been faulted for sketching too much. When ideas present themselves, sketch them immediately. When they don't present themselves, stop sketching and work on something else. Give your mind a chance to refresh itself.

Genius is the ability to reduce the complicated to the simple.
—C. W. Ceram

Teledesi

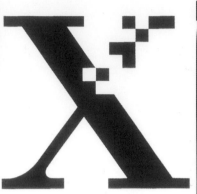
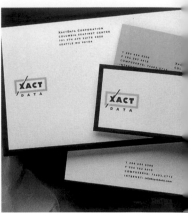

ONKYO

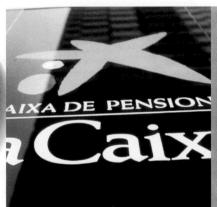

abstract impressions

most companies mold the focus of their message into an ideal, marketable image that they offer to prospective clients, associates, and interested outsiders, hoping that the brand will leave its mark. This symbolic corporate emissary is often driven by abstract concepts—such as banking services, conglomerate investment interests, creative and advertising services—that offer few clues to its essential character. Logos designed to establish a broad visual presence (unlike those for tangible products or concrete services, which we presented previously) must rely solely on their refined form and distinctive style to get noticed. They must work harder to proclaim, in a symbol their customers will understand, "I am"

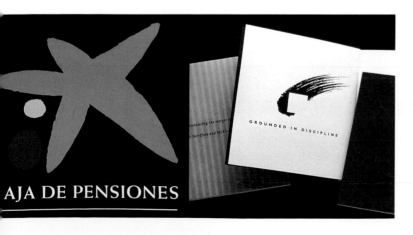

business to business

9

C H A P T E R

Change requires flexibility. Absolute change requires absolute flexibility. What do you do when the logo you're designing is meant to represent business in a field that in all likelihood does not exist yet? Ten years ago, this would have been an absurd question. Nothing in commerce advanced or changed so quickly that companies would come into existence and prepare for waves of business in fields that had not even become theoretical. But then, they weren't dealing with the true dawn of the computer age. Just as how-to books about computers generally become obsolete before they reach bookstore shelves, the pace of expanding technology has swept businesses along at previously unheard of speeds—swamping some and lifting others to unimaginable heights.

It is difficult enough for the people running these companies to predict what form the next technological advance will take and how the company will grow and change to stay with it. For a graphic designer attempting to create a visual identity for a company like this, it is extremely challenging. Just a few years ago, who would have guessed that the means to create a fully

animated logo—and the equipment to view it—would be right at the average person's fingertips. The next advance (which will likely be passé by the time we finish writing this sentence) appears to be 3D animated imaging for the World Wide Web. What will come after that is anybody's guess.

And as for imagery trends, only a very few have emerged. Since the equipment can suddenly support it, cleaner, less hi-tech–looking logos have replaced the harder-edged, more digital-looking images that were designed to survive low-resolution viewing. The splashy, obviously computer-generated visuals—swirled images, multiple overlays and fades, heavy airbrushing—that burst onto the scene

when the first group of designers got hold of Kai's Power Tools for Photoshop and similar software, are also fading in favor of simpler logos. Although that same software may be the current and future industry standard, designers are now discovering its subtleties and putting them to use.

The overall trend in design for technology-based businesses, services, and concepts seems to emulate the underlying trend in the technology itself. As computers improve, they will become simpler and attract less attention. This is analogous to the televisions of a few decades ago. Not only did previous generations of viewers have to get up to change channels, they had to fuss with antennas, know how to tune in stations, know how to set vertical and horizontal holds, and so on. It actually took a certain amount of technical skill to watch TV. Today, one-touch tuning does it all. Soon computers will be equally unchallenging for the average user. In terms of visual identity, this means showing enticing colors, refined lines, and nonthreatening simplicity. Remember when Dorothy peeked behind the curtain in the *Wizard of Oz*? Imagine it in reverse—a nice friendly human face out front and a really powerful silicon genie behind the drapery. This is where technology is headed. The logos that represent it need to emphasize that friendly facade.

Fiberlink, a full-service telecommunications provider, developed its business focus around local phone-service customers, specializing in the next wave of telecommunications services. The company changed its name from Fiberlink to NextLink to a project a forward-thinking image and to allow for further flexibility as the exact nature of the firm evolves. After changing its name, the company asked Hornall Anderson Design Works (HADW) to create an appropriate identity for their new venture. When HADW took on the project, the main challenge was to avoid the pitfall of ambiguity. Traditionally, companies that are extremely diversified—or

CLIENT: NextLink Corporation
Bellevue, Washington
DESIGN FIRM: Hornall Anderson
Design Works, Inc.
Seattle, Washington
ART DIRECTOR: Jack Anderson
DESIGNERS: Jack Anderson,
Mary Hermes, David Bates,
John Anicker, Mary Chin Hutchison

This full-service telecommunications provider has developed its business focus around local phone-service customers, specializing in the next wave of telecommunications services. The company changed its name from Fiberlink to NextLink to a project a forward-thinking image and to allow for further flexibility as the exact nature of the firm evolves. HADW created an identity using custom lettering and bold colors. The use of the slightly askew, leaping *X* illustrates the company's leap into the future as well as the unknown factor of what comes next.

111

lacking in direction—are represented by noncommittal emblems. It wasn't that the management at NextLink didn't know where the company was going. It was very consciously planning to head into technology's unknown. It was up to HADW to build an identity around this and to create an image that would speak for the company.

The known factors—technology and the company's aggressive approach to it—reveal themselves in the design team's dynamic solution. The team kept the logo simple and thus more flexible by using straight text. However, in a demonstration of what can be accomplished when creative thought is applied to even the most basic materials, the design team managed to reflect the company's leap-forward approach. The leaping *X* clearly represents both this and the x factor of the unknown technologies. The human-friendly warmth and simplicity of the technology's interface are presented via the easy-to-read, straight block text and the multicolored *X*.

Will this design hold up in the unknown world of the future? It certainly will fare better than logos that use concrete visual images such as telephones or computer circuitry, which are liable to become rapidly out of date. And the straight text also will function better in the cross-cultural environment of global communications.

NEXTLINK

Julie L. Brown
Executive Assistant

155 108th Ave. NE, 8th Fl.
Bellevue, WA 98004
206.519.8913
1.800.254.9030
fax: 206.519.8910
julieb@nextlink.net

FREE CELLULAR CALLING

CLIENT: Toll-free Cellular
Seattle, Washington
DESIGN FIRM: Hornall Anderson
Design Works, Inc.
Seattle, Washington
ART DIRECTOR: John Hornall
DESIGNERS: John Hornall, Heldi
Favour, Jana Nishi, Julie Lock,
Mary Chin Hutchison,
Bruce Branson-Meyer

This cell-phone service provides free cellular phone calls by dialing #800 before the advertisers' phone numbers. The logo's objective was to make sure that users knew there was more to come; the suggestion of the notion of a phone call process based on the use of telephone buttons. HADW's design conveys the notion that these numerical prefixes are only part of a whole system. A connecting device protruding from the last digit acts as a precursor suggesting that there is more to come. The bold type treatment allows for easy recognition in any context or at any distance.

T I P

If you are looking for outside influences, study the masters of whatever style you wish to learn or emulate. What you study and the images you expose yourself to often will have influences on your work. If you want your output to be the best, make sure your input is, too.

CLIENT: Onkyo Corporation
Tokyo, Japan
DESIGN FIRM: Hornall Anderson
Design Works, Inc.
Seattle, Washington
ART DIRECTOR: Jack Anderson
DESIGNERS: Jack Anderson, Lisa
Cerveny, David Bates, Julie Keenan

This Japanese electronics company was bought out by another Japanese client. The new identity had to reflect the merger as well as an Americanization of the brand: a badge placed on every component. HADW's finalized version was incorporated in a box, representing a stereo component, with the two *O*s, depicting dials or knobs. Use of bold, uppercase letters with a solid black box improved the icon's impact and recognition on store shelves.

CLIENT: XactData Corporation
Seattle, Washington
DESIGN FIRM: Hornall Anderson
Design Works, Inc.
Seattle, Washington
ART DIRECTOR: Jack Anderson
DESIGNERS: Jack Anderson,
Lisa Cerveny, Jana Wilson,
Julie Keenan

This distributive system backup company wanted an identity that would represent its services. HADW's design solution was to use an *X* within a box as a representation of an exact and safe system contained within a vault.

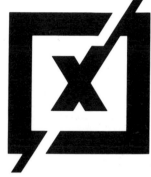

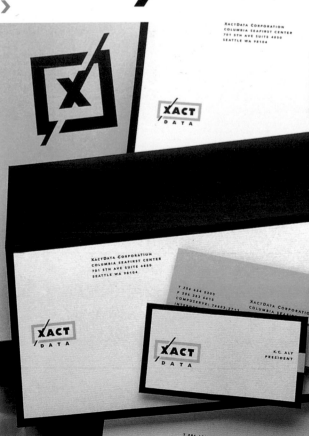

THE UNKNOWN QUANTITY

Logos that communicate known factors, such as products or services that have concrete identities, are relatively easy to design. But there are many businesses that don't have familiar symbols to use as a focal point. So where do you find the elusive imagery that will attract attention to your client's image and create the intended impression? A great place to start your research is by asking your clients what they anticipate doing with their business one, two, or five years from now. Do they see themselves quickly diversifying their interests? Do they have an idea where they're headed in the future? Look for emotional clues in your interview. Maybe your clients intend to leap into the future like NextLink. Maybe your clients want to create an anchored position, a stabilizing entity in an uncertain world. Try sketching as soon as you finish speaking with your clients, since first impressions are what you want to capture.

CLIENT: MIDCOM Communications
Seattle, Washington
DESIGN FIRM: Hornall Anderson
Design Works, Inc.
Seattle, Washington
ART DIRECTOR: John Hornall
DESIGNERS: John Hornall,
Jana Nishi, David Bates

This independent, northwestern telephone utility offers a variety of multiple-carrier products and services. As the nation's largest and fastest-growing reseller of long distance services, MIDCOM decided to realign its image and market position. HADW created an identity that symbolized information exchange. This was enhanced through the interlocking of the *C* and *O*. In color, the logo incorporates a two-color gradation of these letters, further emphasizing transition and movement.

› MIDCOM

CLIENT: Teledesic
Kirkland, Washington
DESIGN FIRM: Hornall Anderson
Design Works, Inc.
Seattle, Washington
ART DIRECTOR: Jack Anderson
DESIGNERS: Jack Anderson,
Leo Raymundo

HADW was commissioned to develop an identity for a one-thousand channel low-earth-orbit satellite system that provides two-way wireless communication quickly and efficiently around the globe. In addition, the identity needed to change the focus from the company's current telephone-directory image to an exciting "wired" image, allowing the firm to position itself against other proposed broadband communication networks and to attract investment participation from within the high-tech community.

CLIENT: Shapiro
Seattle, Washington
DESIGN FIRM: Hornall Anderson
Design Works, Inc.
Seattle, Washington
ART DIRECTOR: Jack Anderson
DESIGNERS: Jack Anderson,
Julie Lock, Lian Ng

The design solution for this environmental engineering consulting company incorporated the subtle shape of an *S* in its design. The waves represent both organic and water symbology: nature working with humans or man-made elements, such as buildings, and nature flowing/ interfering with architecturally made elements. Together they enhance the company's environmentally conscious attitude toward engineering.

CLIENT: Mahlum & Nordfors McKinley Gordon
Seattle, Washington
DESIGN FIRM: Hornall Anderson
Design Works, Inc.
Seattle, Washington
ART DIRECTOR: Jack Anderson
DESIGNERS: Jack Anderson,
Scott Eggers, Leo Raymundo

The intent of this logo was to visually depict the merger between two architectural design firms with diverse backgrounds and working styles: one being more structure, discipline, and engineering driven and the other being more focused on unique solutions and creativity. HADW devised an illustrative solution: The brush stroke represents a more artistic and creative vision, while the cube is iconic for an architectural, logical ideology.

GROUNDED IN DISCIPLINE

Announcing the merger of
Mahlum & Nordfors and McKin

Simplicity,
carried to an extreme,
becomes elegance.
—*Jon Franklin*

cf2GS

CLIENT: Christiansen, Fritsch, Giersdorf, Grant & Sperry, Inc. Seattle, Washington
DESIGN FIRM: Hornall Anderson Design Works, Inc. Seattle, Washington
ART DIRECTOR: Jack Anderson
DESIGNERS: Jack Anderson, David Bates

The marketing communications firm of Christiansen Fritsch Giersdorf, Grant & Sperry, Inc., needed a new identity that promoted the corporate feel of the firm while possessing the combined personality of the partners, who are distinctly individual creative powers. The company also wanted to create a name that would be more memorable. HADW's design solution incorporates a far more memorable and easy-to-use acronym. The straightforward design direction, the innovative uppercase and lowercase treatments, and the selection of an attractive and fun color palette all combine to make the mark visually effective. The stationery program continues the creative use of color: The back of each of the partners' business cards highlights his or her last initial, while the employees' cards have the company "2" featured on the back.

普通預金通帳

店番　口座番号

神田信用金庫

様

KANDA SHINKIN

神田信用金庫　様

座通帳

口座番号

KANDA SHINKIN

◀ CASH CARD (法人用)　　KANDA SHINKIN

神田信用金庫

CLIENT: Kanda Skinkin
Tokyo, Japan
DESIGN FIRM: Desgrippes Gobé
& Associates
Tokyo, Japan

Blatant symbolism and subtle design
cues combine as the backbone of a
determined policy to clarify this
bank's position among its competitors.
A symbol of trust, presented in a
background that communicates
sensitivity and modernity, this
identity clearly tells the public that
this is a people's bank.

T I P

Frank Lloyd Wright
would often camp out
on land where he'd been
commissioned to build
a house before he formu-
lated a design. Get to
know your client's
business as well as you
can—the visual solution
may present itself.

The obvious is that which is never seen
until someone expresses it simply.
—*Kahlil Gibran*

117

CLIENT: Lucent Technologies
Murray Hill, New Jersey
DESIGN FIRM: Landor Associates
San Francisco, California
(corporate office)

When telecommunications giant AT&T was ordered to split itself into three separate companies, including AT&T (long-distance service) and NCR (computers), the third company—Lucent Technologies—didn't have a preexisting name or identity. Consisting of Bell Laboratories and four primary divisions, each segment of the company has a distinct market and mission, but all of them share common attributes such as speed, energy, innovation, and technology. Landor developed the firm's name by concentrating on the company's spirit: "glowing with light" and "marked by clarity." The dynamic, humanly drawn circle evokes the emotional appeal of human communication that's been enabled by improved technology.

Lucent Technologies
Bell Labs Innovations

CLIENT: Xerox Corporation
Stamford, Connecticut
DESIGN FIRM: Landor Associates
San Francisco, California
(corporate office)

Xerox Corporation is another example of a company name that has been adopted as an active verb by the general public. Even though this strong branding has made the company a world leader, it was time to incorporate a youthful look to the company that evoked creativity and flexibility. After extensive research, Landor recommended emphasizing the phrase "The Document Company" before the familiar Xerox name, clearly communicating the company's ability to handle all document-related products and services. The partially digitized red *X*—an additional iconographic element—was created to increase Xerox's presence in print, advertising, packaging, and promotions.

The Document Company

CLIENT: Telenor
Olso, Norway
DESIGN FIRM: Landor Associates
San Francisco, California
(corporate office)

The Norwegian telecommunications market has grown during the past few years, especially in the international sector. To present this all-encompassing business approach, Telenor International Group asked Landor to create an icon that would reflect its ability to harness and work with the power of communications both domestically and globally. The finished solution evokes the electronic and human natures of the business as well as an insinuation of its worldwide scope.

›

CLIENT: Bruce Clark Productions
Seattle, Washington
DESIGN FIRM: Hornall Anderson
Design Works, Inc.
Seattle, Washington
ART DIRECTOR: Jack Anderson
DESIGNERS: Jack Anderson,
Heidi Favour, Mary Hermes

⌄

This tradeshow fabricator/manufacturer needed a logo that reflected its abilities in the field. HADW's eye logo incorporates a vision of creativity and exactness—essential business elements. The eye's pupil also incorporates a *C*, representing the company's name. The total icon emphasizes how the company strives to create visually appealing tradeshows and exhibits.

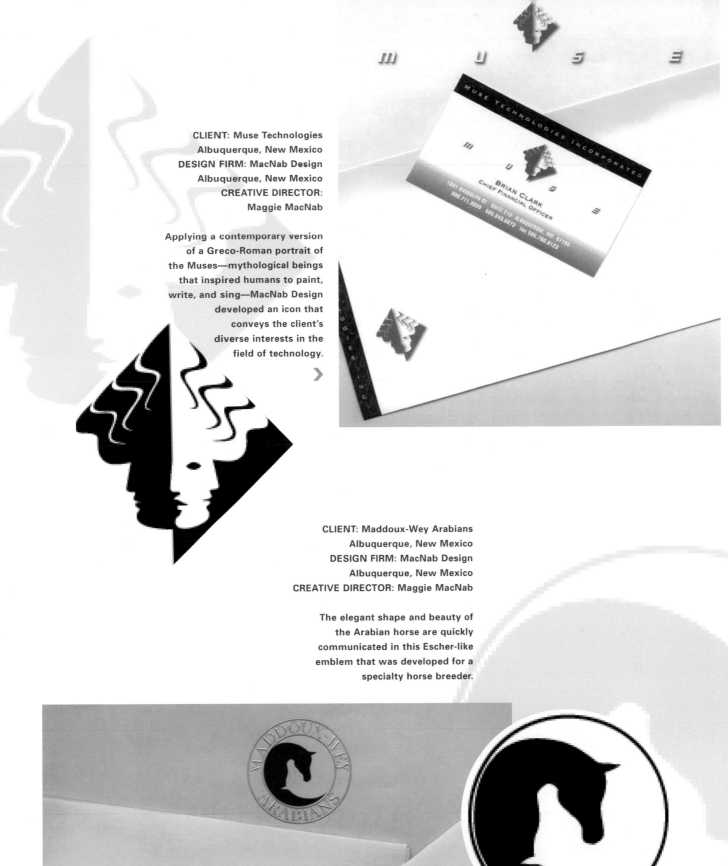

CLIENT: Muse Technologies
Albuquerque, New Mexico
DESIGN FIRM: MacNab Design
Albuquerque, New Mexico
CREATIVE DIRECTOR:
Maggie MacNab

Applying a contemporary version of a Greco-Roman portrait of the Muses—mythological beings that inspired humans to paint, write, and sing—MacNab Design developed an icon that conveys the client's diverse interests in the field of technology.

CLIENT: Maddoux-Wey Arabians
Albuquerque, New Mexico
DESIGN FIRM: MacNab Design
Albuquerque, New Mexico
CREATIVE DIRECTOR: Maggie MacNab

The elegant shape and beauty of the Arabian horse are quickly communicated in this Escher-like emblem that was developed for a specialty horse breeder.

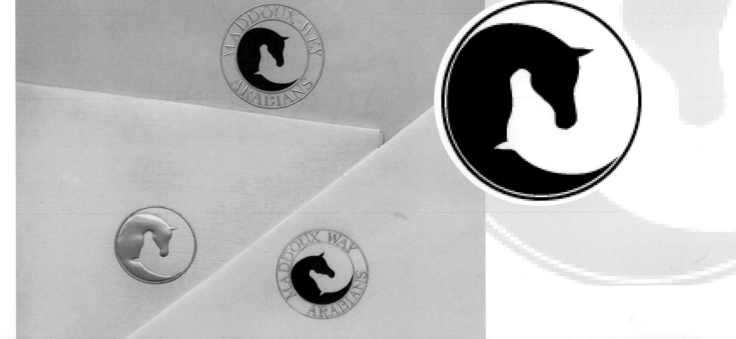

epic

EPIC Technologies, LLC

6501 Americas Parkway NE

Suite 1050

Albuquerque

New Mexico 87110

505 888 1996 voice

CLIENT: EpicTechnologies
Albuquerque, New Mexico
DESIGN FIRM: MacNab Design
Albuquerque, New Mexico

A lucid wave of water serves as
the central focus for this company's
identity. This image is coupled
with a desert color palette to
communicate the firm's locations
in New Mexico and Nevada as well
as its primary business function:
water-based remediation for
nuclear power sites.

CLIENT: Bohannan-Huston
Albuquerque, New Mexico
DESIGN FIRM: MacNab Design
Albuquerque, New Mexico

A cross section of an engineer's
scale serves as the central focus
of both the previous logo and
MacNab Design's identity update
for this engineering, surveying,
and landscape-architecture firm.
A fresh color palette and additional
graphic elements further enhance
the new look.

›

Courtyard One

7500 JEFFERSON NE

Albuquerque

NEW MEXICO 87109

voice 505.823.1000

fax 505.821.0892

CAJA DE PENSIONES

"la Caixa"

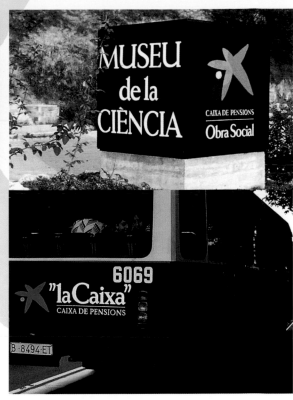

›

CLIENT: Caja de Pensiones
Barcelona, Spain
DESIGN FIRM: Landor Associates
San Francisco, California (corporate office)

Studies conducted by this Spanish bank revealed that no one understood the institution's social and financial activities. To clarify this as well as reintroduce its persona, Landor commissioned artist Joan Miró to create a tapestry that would incorporate a star to capture the bank's Spanish and Catalonian heritage. Also known as "la Caixa," the bank opened its visual identity by including touches that allude to its involvement with both cultural and community-based programs.

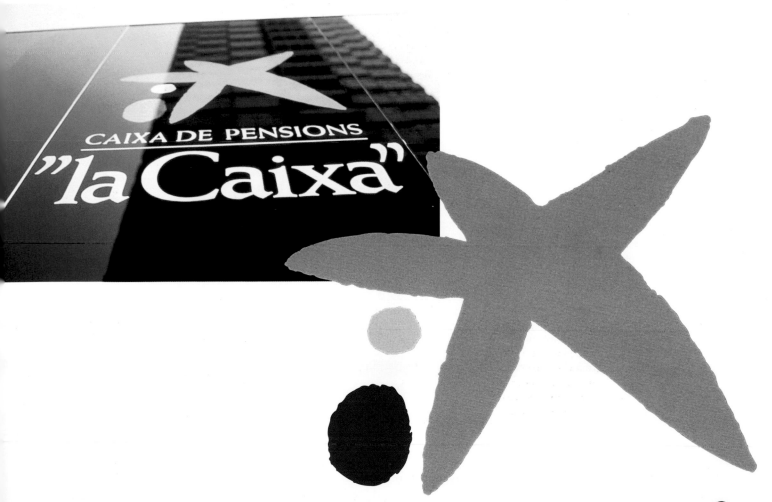

creative services

(d)esigners and design studios generally lean toward very simple and generic identities for their businesses: a conservative or classic serif or sans serif text, a blueprint-style sketch with an unfinished feel. There's a very good reason for this: If potential clients are presented with a strong design studio identity, they may judge the studio based on this one item—and whether or not they feel like it fits their needs—rather than looking at the studio's samples and sketches. They may be right, too. Studios that create very stylized identities for themselves are in effect saying for better or worse, ''Here's the style I work in. This is it!'' With that in mind, it shouldn't come as a surprise that some of the most renowned and successful studios have some of the most basic logos.

CLIENT: Jay Vigon Studio
Studio City, California
DESIGN FIRM: Jay Vigon Studio
Studio City, California

You think it's a great idea; the client has something else in mind. What do you do with those great ideas which never got used? Jay Vigon took his and opened Made On Earth, his highly successful shop on Ventura Boulevard. The Made On Earth image itself was originally designed for I-Works' Cinetropolis giant-screen movie theaters. This is perhaps the best proof out there that just because a client turns down a design, it doesn't mean the design isn't fabulous—it just means it didn't work for the client.

›

''So when do I get to do something creative?'' If you've ever hired a student intern, you might have heard this question or something similar. And if you've been in the creative business a while, you know that the ratio of time spent being creative versus time spent taking care of business is definitely weighted 80 percent in favor of the latter.

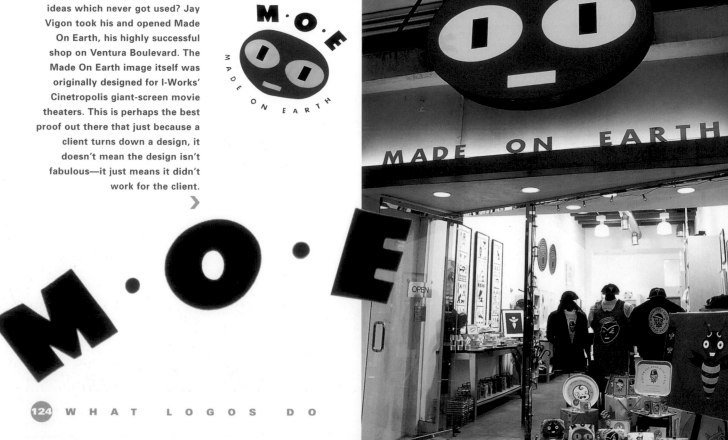

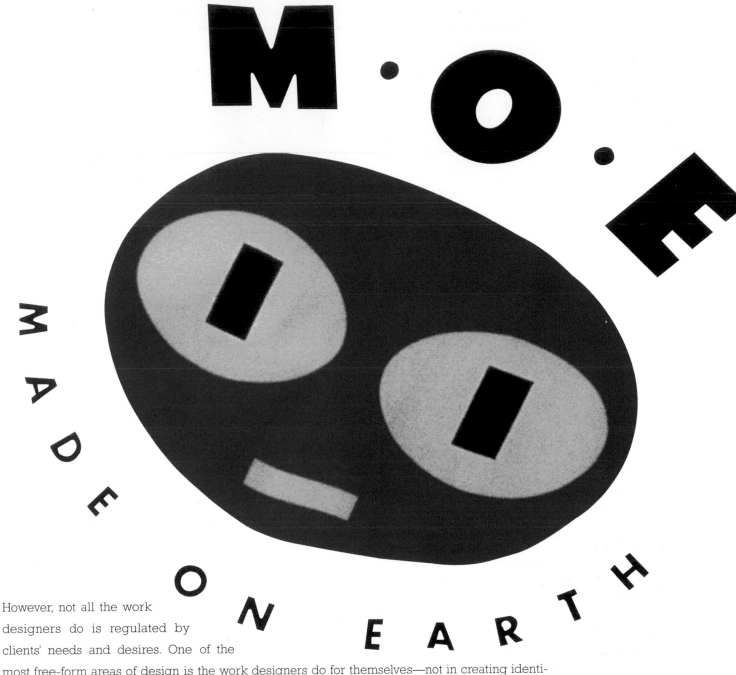

M.O.E

MADE ON EARTH

However, not all the work designers do is regulated by clients' needs and desires. One of the most free-form areas of design is the work designers do for themselves—not in creating identities for their own studios but as an outlet for the random ideas that fill the heads of all creative people from time to time. As designer Jay Vigon demonstrates, these ideas that aren't created for a client—that are purely design for the love of design—or even ideas that are turned down by clients, can be as rewarding as any commissioned project.

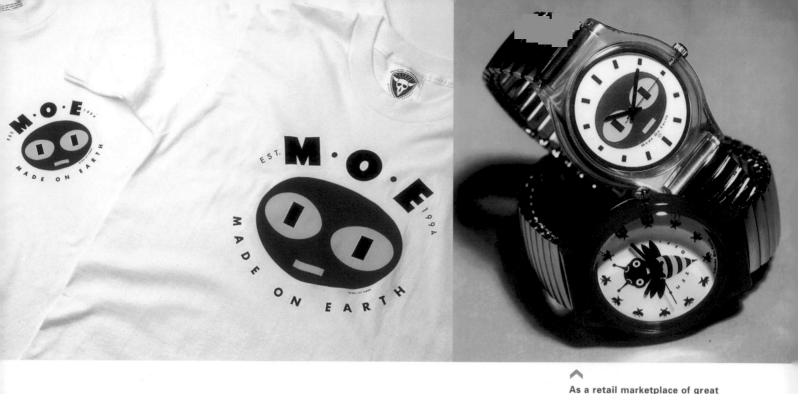

As a retail marketplace of great
design, Made On Earth sells an
eclectic mix of clothing,
housewares, and art. Pieces like
these demonstrate the visual
power that can be created when
the artist gets to control image
placement and, knowing the
images better than anyone, can
specify where they'd work the
best. Even with this much
artistic freedom, however, it still
takes good business sense to
make a product successful.

One of Vigon's purely personal logos is his Natural Cycle Club series. Although it
wouldn't be out of place tattooed across a Harley owner's bicep, it is not about motor-
cycles. Natural Cycle Club was born from a visual conceptualization of Darwinism
Vigon had one day, focusing on the natural cycle of life from birth through death and
rebirth (see Natural Cycle Club, Chapter 4).

Another of Vigon's creations emerged from an idea he had about a universal logo,
something that would become relevant in a distant time when interstellar trade would
necessitate a Made on Earth logo. He sketched it as a possible identity for I-Works'
Cinetropolis giant-screen movie theaters, but the company declined.
He briefly set it aside while he was busy directing commercials
in Hollywood, but he wasn't quite ready to let it go.

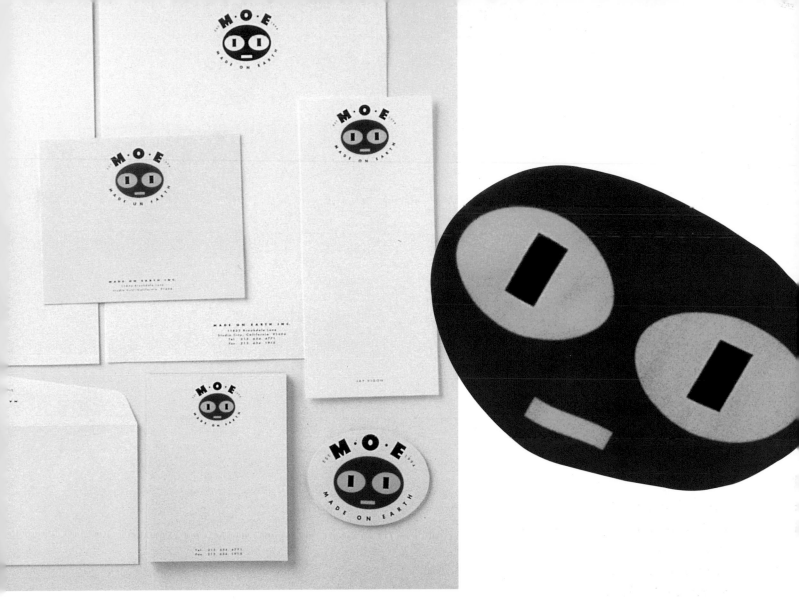

Even though he stopped actively pursuing design clients around 1993, Vigon continues to take on occasional projects, and he never stopped sketching his ideas. This collection grew into his highly successful Made On Earth retail store on Ventura Boulevard, which opened in November of 1996 and sells items from clothing to cocktail glasses sporting these and other logos he has created, as well as framed prints of select pieces of his work.

Some of the logos in the store were created especially for it, or were inspired by his young daughters ("Baby Eika" and "Twisted Kitty" are two of the works they inspired). Others are pieces that were actually turned down by clients. You could call them the "option B" works. These pieces, silk-screened onto T-shirts simply as images without any commercial references, have become some of Made On Earth's top-selling items.

It is not surprising that these items are selling so well. By breaking away from individual clients and producing work for himself, Vigon has had the enviable opportunity to explore and build on his engaging style—and get carried away. It is also no surprise that many of his best customers are also in the design business; though droves of tourists and locals pour into the store every day, who could better appreciate a designer who's found an unrestricted outlet for his creativity than another designer.

This angel/devil image was created originally for a film production company that was affiliated with Fahrenheit Films, for which Jay Vigon created a burning-devil logo. After the sister company opted not to use the image, it became one of the hottest-selling items in the store.

It is proof of high culture to say the greatest matters in the simplest way.

—*Ralph Waldo Emerson*

However, if the business of design is so restrictive, why do so many people aspire to it? Asked why she chose design as a profession, one designer replied: "I design because no matter what I've tried to do in life, it's always led straight back to design. I got into the restaurant industry and found myself designing menus. I worked in administration for a small college and found myself redesigning their identity. It's always been that way. I didn't choose design. Design chose me."

‹

CLIENT: Rod Ralston Photography
Seattle, Washington
DESIGN FIRM: Hornall Anderson
Design Works, Inc.
Seattle, Washington
ART DIRECTOR: Jack Anderson
DESIGNERS: Jack Anderson,
Julie Keenan

The development of this logo
started with the intent to upgrade
the overall look, appealing to a
broader customer base. HADW
studied basic photography
components and how they could
visually represent looking through
a lens. Using the photographer's
initials, HADW showed how an
object looks to the naked eye as
well as through the camera's lens.
It says photography at the
simplest level, making for a
quick consumer read of the
essential message.

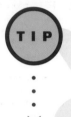

TIP

If you have an idea that
you love but isn't right
for your client—and you
know it isn't—set it
aside. Don't discard
your good ideas. Collect
them, save them, accu-
mulate them as an idea
bank for the future. Then,
when the pressure is on
to create, you'll never
find yourself transfixed
by a blank page.

The art of art, the glory of expression and
the sunshine of the light of letters is
simplicity: nothing is better than simplicity.

—*Walt Whitman*

The best designer is an invisible designer. Paul Rand, famed for his logo design work for companies such as ABC-TV and Westinghouse, didn't achieve notoriety by creating designs that people would look at and say, "That must be a Paul Rand." He achieved it because when people see his work, they say, "That's IBM," or "That's UPS." Separate yourself from your work and design invisibly.

CLIENT: Interactive Bureau
New York, New York
DESIGN FIRM: Interactive Bureau
New York, New York
CREATIVE DIRECTOR: Roger Black
DESIGNER: Roger Black

Well known for designing dynamic, eye-catching logos, it's no surprise that IAB would create this fire-engine red, superbold exclamation mark paired with a question mark for itself. It makes a statement that if you've got a question, this company knows how to make a statement. In full animation on the World Wide Web it rotates, transforming into a question mark, and back, with every turn.

YOU'RE ONLY AS GREAT AS YOUR SCRAP FILE

Ideas never seem to follow a reasonable nine-to-five schedule. A concept can occur when and where it likes, triggered by a passing comment, a scene in a film, a sentence in a novel. Some of the world's greatest logo designers are scribblers and pack rats. They don't need a client or project to stimulate their creative juices; they seem to be in a constant state of acquiring visual inspiration and synthesizing new concepts. Even though we live in a computer-oriented society, you should get in the habit of maintaining a design journal. Clip out visuals you find interesting and paste them into a blank book. Draw an image that comes to mind. Keep your rejects in a scrapbook or file. It won't take long before you've accumulated a treasure chest of resources that you can use to trigger your imagination on a live project.

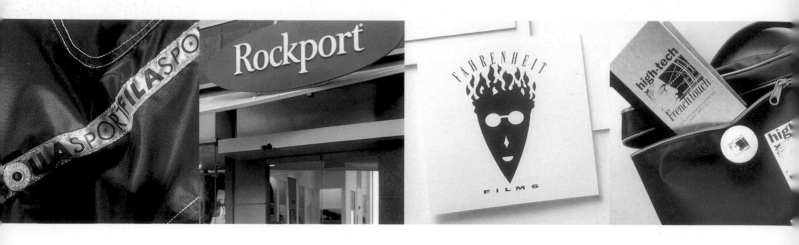

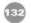

biographies

Desgrippes Gobé & Associates

411 Lafayette Street, New York, NY 10003

Phone: 212/979-8900

Fax: 212/979-1401

Marc Gobé is president, CEO, and executive creative director of Desgrippes Gobé & Associates, which the *Financial Times* of London listed as one of the world's top ten strategic design and image management firms. With offices in New York, Paris, Tokyo, and Seoul, the firm tailors its marketing and creative teams to best meet the needs of its international and local clientele.

Gobé's broad experience in packaging, corporate and brand identity, and retail architecture reflects the creative range of his clients. From Ann Taylor to The Limited Corporation, from Mark Cross to Godiva Chocolatier, from IBM to Coca-Cola, Desgrippes Gobé has consistently been a trusted consultant and an innovator in creating strong retail-presence programs that generate both an emotional attachment and trust with intended consumers.

Committed to the creation of corporate identity (naming and print collateral), packaging (graphic and structural), and retail presence programs (corporate identity, graphics, signage, architecture, fixturing, and merchandising combined), this firm has pioneered S.E.N.S.E., a unique three-phase methodology that analyzes a brand's existing visual equities, develops and targets critical marketing cues and symbols that speak to consumers' tastes and values, and implements the necessary programs to achieve the refined goal.

Duffy Design

79 Fifth Avenue, 14th Floor, New York, NY 10010

Phone: 212/337-8300

Fax: 212/206-0489

Started in 1984 by Joe Duffy and the partners of Fallon McElligott advertising in Minneapolis, Duffy Design has worked on international identity programs for clients such as Ameritech, Giorgio Armani, Black & Decker, Chaps/Ralph Lauren, Coca-Cola, Jaguar, Jim Beam, Lee Jeans, Minute Maid, Timex, and brands of The Stroh Brewery Company. In January of 1994, Duffy Design became a part of Fallon McElligott and one year later opened Duffy New York, which partnered up with Fallon McElligott Berlin in New York to offer clients a complete branding package including advertising and identity development.

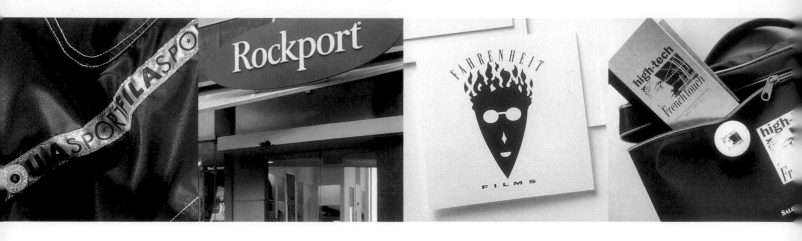

M·O·E

MADE ON EARTH

Hornall Anderson Design Works, Inc.

1006 Western Boulevard, Sixth Floor, Seattle, WA 98104

Phone: 206/467-5800

Fax: 206/467-6411

When John Hornall and Jack Anderson founded HADW in 1982, they brought between them thirty years of design experience and achievement. The firm has two main goals: to give clients design solutions in tune with their marketing objectives and to do the best work in the business, striving to elevate every job above the ordinary. HADW focuses its design efforts on identity programs, collateral materials, signage, packaging, promotional graphics, and sports graphics. With the success of identity programs for Starbucks Coffee Company, Airborne Express, Corbis, K2 Corporation, Intel Corporation, Microsoft Corporation, and Onkyo, the firm continues to concentrate not only on Fortune 500 corporations but also on small, local businesses.

Jay Vigon Studio

11833 Brookdale Lane, Studio City, CA 91604

Phone: 213/654-4771

Fax: 213/654-1915

Jay Vigon earned his reputation as a premiere logo designer for record-album and motion-picture projects such as *Return of the Jedi* and *Purple Rain*, as well as corporate accounts such as Gotcha Surfwear and Cole of California. During the 1980s he teamed up with Rick Seireeni to establish Vigon Seireeni, a design and advertising firm. Vigon has authored two books of his memorable logo designs—Marks and Marks II—and has currently expanded his vision by directing commercial spots and opening Made On Earth—a store that's dedicated to wearable logos.

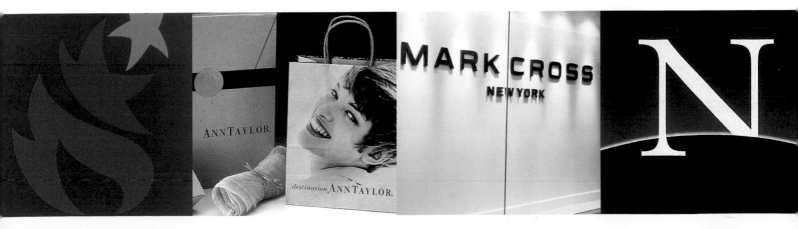

Landor Associates

1001 Front Street, San Francisco, CA 94111

Phone: 415/955-1400

Fax: 415/955-1389

Founded by Walter Landor after he arrived in San Francisco in 1939, Landor Associates has created some of the world's most recognizable brands and logo systems from Kellogg's Corn Flakes to Royal Viking Line and has developed revitalization programs for Marlboro, Coca-Cola, and Levi Strauss. A rescued ferryboat—the *Klamath*—served as the company's corporate headquarters from 1964 to 1987. The firm has now spread to a dozen additional international locations and continues the tradition of excellence established by its founder for clients such as Federal Express, Northwest Airlines, and Netscape.

Jean-François Porchez

38 bis, Avenue Augustin-Dumont, F-92240 Malakoff, France

Phone: 33-1-46-52-26-92

Fax: 33-1-46-52-26-92

Jean-François Porchez is a two-time winner of the Morisawa International Type Design Award for his FF Angie and Apolline typefaces. Porchez received his masters degree from Atelier National de Création Typographique in 1991 and worked for three years as the type director for the Paris-based corporate identity and packaging firm Dragon Rouge. Besides developing the typographic identity for the French national newspaper *Le Monde*, Porchez recently has designed the typographic treatment for the Paris Metro signage system. He is also a part-time typography teacher and journalist.

directory

Desgrippes Gobé & Associates
411 Lafayette Street
New York, NY 10003
Phone: 212/979-8900
Fax: 212/979-1401

Desgrippes Gobé & Associates
18 bis, Avenue de la Motte Picquet
75007 Paris, France
Phone: 33-1-44-18-14-18
Fax: 33-1-45-51-96-60

Desgrippes Gobé & Associates
3F Pittoresque Building
1-9-12 Ebisuminami
Shibuya-ku
Tokyo 150, Japan
Phone: 81-3-5722-1571
Fax: 81-3-5722-1575

Desgrippes Gobé & Associates
Ago Building, 3d fl
616-6 Shinsa-dong
Kangnam-ku
Seoul 135-120, South Korea
Phone: 82-2-543-5730
Fax: 82-2-543-5731

Duffy Design
79 Fifth Avenue, 12th Floor
New York NY 10010
Phone: 212/337-8300
Fax: 212/206-0489

Hornall Anderson Design Works, Inc.
1006 Western Boulevard
Sixth Floor
Seattle, WA 98104
Phone: 206/467-5800
Fax: 206/467-6411

Interactive Bureau
251 Park Avenue South
10th Floor
New York, NY 10010
Phone: 212/293-7200
Fax: 212/292-1914

Jay Vigon Studio
11833 Brookdale Lane
Studio City, CA 91604
Phone: 213/654-4771
Fax: 213/654-1915

Landor Associates
1001 Front Street
San Francisco, CA 94111
Phone: 415/955-1400
Fax: 415/955-1389

Landor Associates
230 Park Avenue South
7th Floor
New York, NY 10003
Phone: 212/614-5050
Fax: 212/614-3966

Landor Associates
1301 Fifth Avenue
Suite 1600
Seattle, WA 98101
Phone: 206/505-7500
Fax: 206/505-7501

Landor Associates
One East Wacker Drive
Chicago, IL 60601
Phone: 312/755-0115
Fax: 312/755-7681

Landor Associates
Courvoisier Centre II
601 Brickell Key Drive
Suite 900
Miami, FL 33131
Phone: 305/347-1980
Fax: 305/347-1981

Landor Associates
Bosque de Duraznos No. 61
11700 Mexico DF
Phone: 52-5-246-0260
Fax: 52-5-246-0277

Landor Associates
Klamath House
18 Clerkenwell Green
London EC1R 0DP, UK
Phone: 44-171-880-8000
Fax: 44-171-880-8001

Landor Associates
19 rue Valette
75005 Paris, France
Phone: 33-1-40-46-97-97
Fax: 33-1-40-46-08-06

Landor Associates
Pickhuben 6
Sandtorkaihof
20457 Hamburg, Germany
Phone: 49-40-378-5670
Fax: 49-40-378-56718

Landor Associates
Piazza Eleonora Duse 2
I-20122 Milan, Italy
Phone: 39-2-7601-2601
Fax: 39-2-7601-2596

Landor Associates
Avenida de Burgos 21-4°
Complejo Triada Torre C
28036 Madrid, Spain
Phone: 34-1-766-6369
Fax: 34-1-766-5871

Landor Associates
17th Floor, Kinwick Centre
32 Hollywood Road
Central Hong Kong
Phone: 852-2851-8173
Fax: 852-2544-9199

Landor Associates
Sogo Hirakawacho Building
6th Floor
1-4-14, Hirakawacho
Chiyoda-ku
Tokyo 102, Japan
Phone: 81-3-3263-2291
Fax: 81-3-3263-2292

MacNab Design
400 San Felipe NW, Suite Four
Albuquerque, NM 87104
Phone: 505/242-6159
Fax: 505/242-7710

MetaDesign
Bergmanstrasse 102
D-10961 Berlin, Germany
Phone: 49-30-695-79200
Fax: 49-30-695-79222

Wolff Olins
10 Regents Wharf
All Saints Street
London N1 9RL, UK
Phone: 44-171-713-7733
Fax: 44-171-713-0216

Jean-François Porchez
38bis, Avenue Augustin-Dumont
F-92240 Malakoff, France
Phone: 33-1-46-52-26-92
Fax: 33-1-46-52-26-92

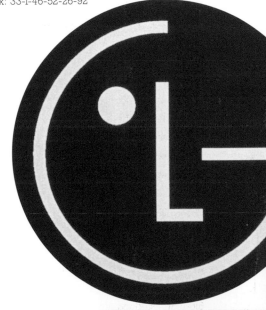

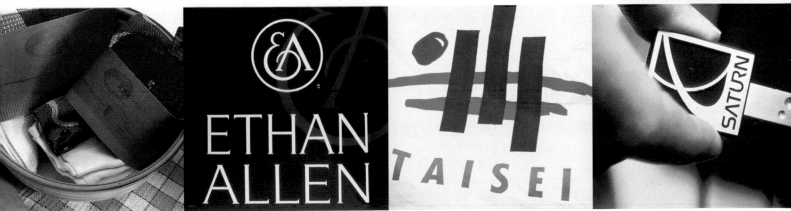

index

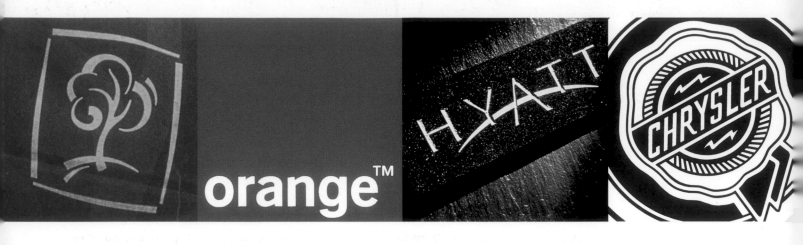

about the authors

Anistatia R Miller and Jared M. Brown are contributing editors at *Adobe Magazine*'s online sister publication *adobe.mag*. Their articles on design and branding also have appeared in *Adobe Magazine* and *U&lc*. They are also coproducers of the award-winning Website *Shaken Not Stirred: A Celebration of the Martini*. (A book based on the Website, by the same name, has been published by HarperCollins Publishers and, in German, by Europa Verlag.) When they've donned their designer hats, they've redesigned the one-hundred-plus-titles *Fodor's Gold Guide* series and *Pocket City Guide* series in 1995 under their studio name, Between the Covers. Ms. Miller was also president of the New York Art Directors Club book division (publisher of the *Art Directors Annual*) and was award-winning design director of *Millimeter* magazine, a trade journal catering to advertising, motion picture, and television production.

acknowlegments

Our heartfelt thanks to the many people who contributed their considerable efforts to bring this book into existence. We would especially like to thank Shawna Mullen, who started the ball rolling; Don Fluckinger who kept it rolling, even when it became an uphill battle; Brian Morgan for pursuing Europe's best contemporary work; Margaret Richardson for her advice; and Lew Grimes, our agent, as always. Thank you all.